FROM THE AIR

IRELAND'S

WILD

ATLANTIC

WAY

RAYMOND FOGARTY

Raymond Fogarty is a professional drone pilot, videographer and photographer based in the south of Ireland. His unique aerial images of the landscapes and scenes from the skies above Ireland are highly acclaimed and have garnered significant attention, both nationally and internationally. His love of technology and of the natural world combine to produce a unique and varied body of work that is used to promote Ireland's natural and man-made beauty. His mission is to inspire future travellers to witness the awe and splendour of Ireland and to be at the forefront of new drone technology with his company AirCam Ireland.

FROM THE AIR

IRELAND'S

WILD ATLANTIC WAY

RAYMOND FOGARTY

THE O'BRIEN PRESS
DUBLIN

First published 2019 by
The O'Brien Press Ltd,
12 Terenure Road East, Rathgar,
Dublin 6, D06 HD27, Ireland.
Tel: +353 1 4923333; Fax: +353 1 4922777
E-mail: books@obrien.ie
Website: www.obrien.ie
ISBN: 978-1-78849-019-1
The O'Brien Press is a member of Publishing Ireland.
Copyright for text & photography © Raymond Fogarty
Copyright for typesetting, layout, editing, design.
© The O'Brien Press Ltd

8 7 6 5 4 3 2 1
22 21 20 19

Printed by L&C Printing Group, Poland.
The paper in this book is produced using pulp from managed forests.

Published in
DUBLIN
UNESCO
City of Literature

CONTENTS

THE WILD ATLANTIC WAY

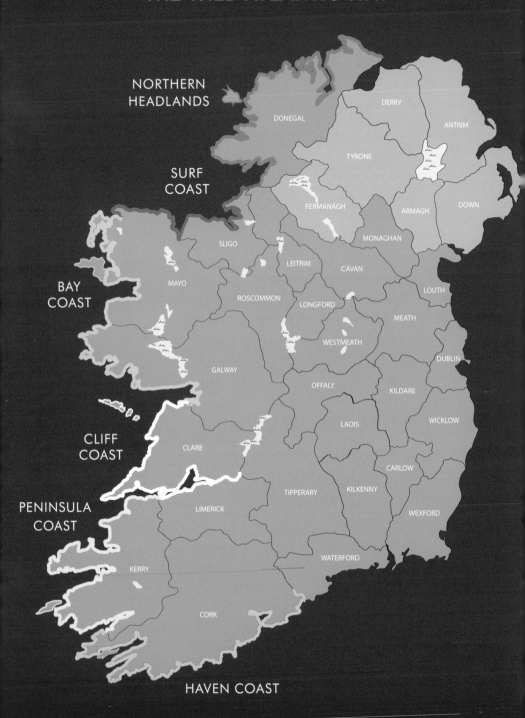

NORTHERN
HEADLANDS

SURF
COAST

BAY
COAST

CLIFF
COAST

PENINSULA
COAST

HAVEN COAST

DONEGAL

DERRY

ANTRIM

TYRONE

FERMANAGH

ARMAGH

DOWN

MONAGHAN

SLIGO

LEITRIM

CAVAN

MAYO

ROSCOMMON

LONGFORD

LOUTH

MEATH

WESTMEATH

GALWAY

OFFALY

DUBLIN

KILDARE

LAOIS

WICKLOW

CLARE

CARLOW

TIPPERARY

KILKENNY

LIMERICK

WEXFORD

WATERFORD

KERRY

CORK

TEN WILD ATLANTIC WAY HIGHLIGHTS

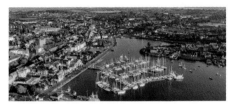

KINSALE, COUNTY CORK. One of the most popular, picturesque and historic towns on the southwest coast.

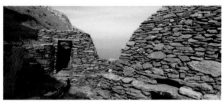

SKELLIG MICHAEL, COUNTY KERRY. Inhabited in ancient times by monks, the UNESCO world heritage site inspires awe.

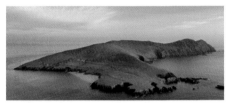

THE BLASKETS, COUNTY KERRY. Ruins from times past and solitary beauty await at Great Blasket Island.

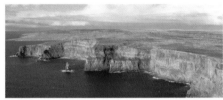

THE CLIFFS OF MOHER, COUNTY CLARE. Perhaps the most famous example of where land and sea collide.

THE BURREN, COUNTY CLARE. A stark, unique and beautiful landscape.

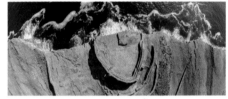

DUN AONGHASA, INIS MÓR, COUNTY GALWAY. Older than civilization, this fort defies nature and time itself.

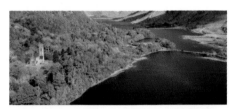

KYLEMORE ABBEY, COUNTY GALWAY. Gothic architecture in stunning Connemara.

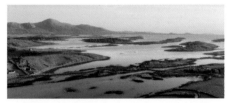

CLEW BAY, COUNTY MAYO. With its 365 islands, probably Ireland's most beautiful bay.

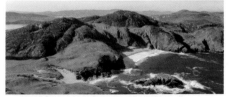

MURDER HOLE BEACH, COUNTY DONEGAL. Only accessible on foot, a spectacular sight awaits.

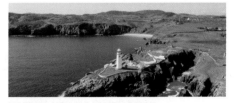

FANAD HEAD LIGHTHOUSE, COUNTY DONEGAL. One of the world's most beautiful lighthouses.

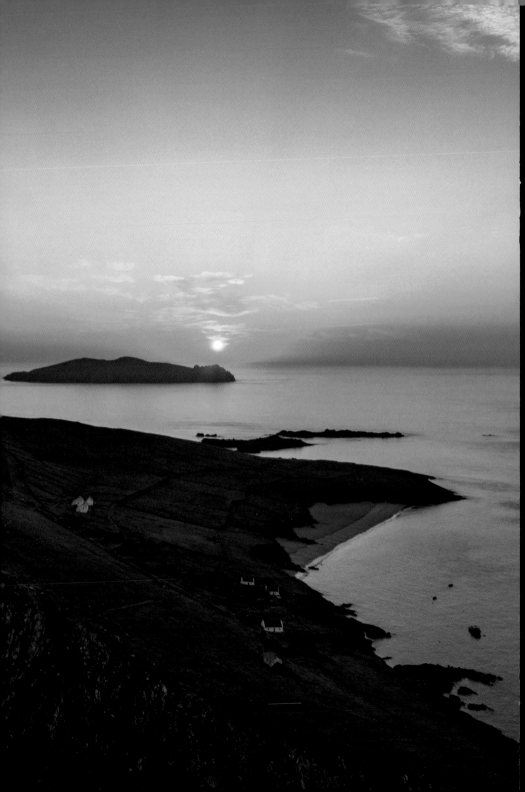

INTRODUCTION

The Wild Atlantic Way is one of the world's longest defined coastal touring routes. Developed by the Irish Tourist Board in 2014, it offers a unified route for a seaboard that existed long before the first humans settled here. Sculpted over millions of years by the Atlantic Ocean, Ireland's west coast stretches through bays and peninsulas for 2,500 kilometres, from Kinsale in County Cork to the Inishowen Peninsula in County Donegal.

For such a small island, the diversity of this pristine western landscape is truly astonishing. Glorious sandy beaches, rolling green hills and towering mountains are all on offer. Dotted throughout is Ireland's ancient heritage of castles, forts and abbeys that stir the imagination. It is an explorer's paradise, with many memorable towns and cities to visit along the way, where the essence of Irish culture and hospitality is to be found.

I first travelled the Wild Atlantic Way in 2014, when both the route and camera drones first appeared. This presented a unique and compelling opportunity to take my drone, travel and photograph the route from above for the very first time. Drones show us a view of our world from never-seen-before angles, places where manned aircraft cannot go. They show us the bigger picture of Ireland's west coast – a world of raw, diverse and ancient beauty that cannot be found anywhere else in the world.

Come with me as I explore the Wild Atlantic Way from the air.

Raymond Fogarty.

February 2019

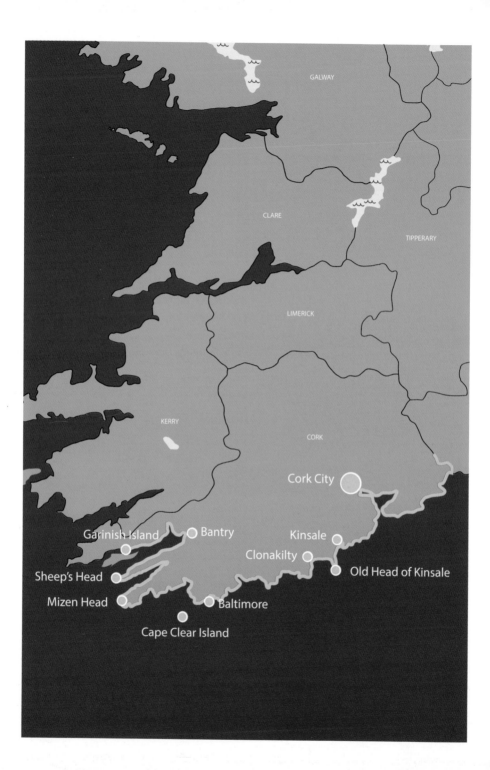

GALWAY

CLARE

TIPPERARY

LIMERICK

KERRY

CORK

Cork City

Garinish Island Bantry Kinsale

Clonakilty

Sheep's Head Old Head of Kinsale

Mizen Head Baltimore

Cape Clear Island

THE HAVEN COAST

From Kinsale to Bantry, explore the expansive coastline of Ireland's largest county, Cork

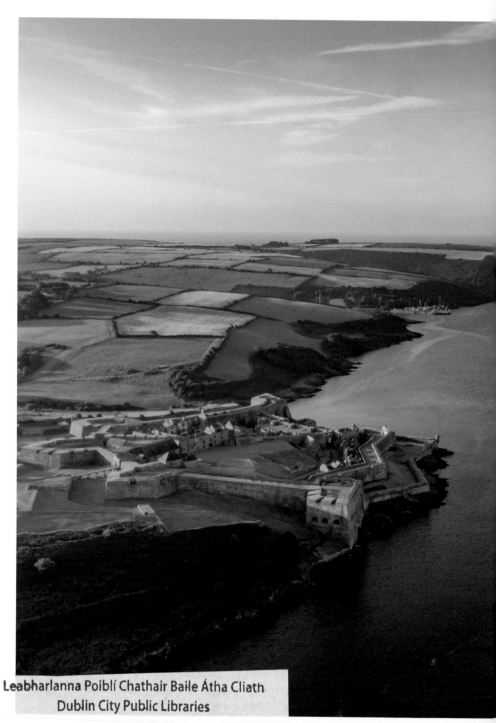

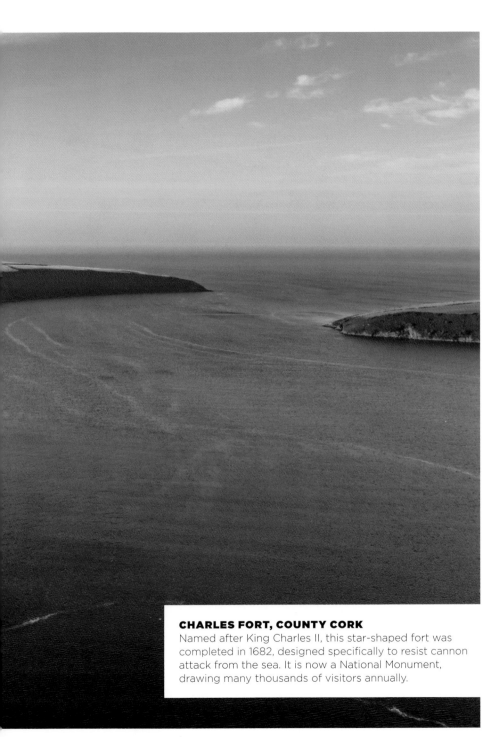

CHARLES FORT, COUNTY CORK
Named after King Charles II, this star-shaped fort was completed in 1682, designed specifically to resist cannon attack from the sea. It is now a National Monument, drawing many thousands of visitors annually.

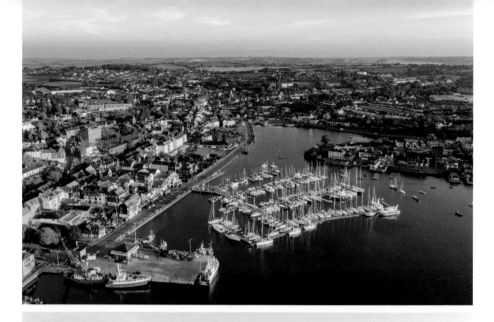

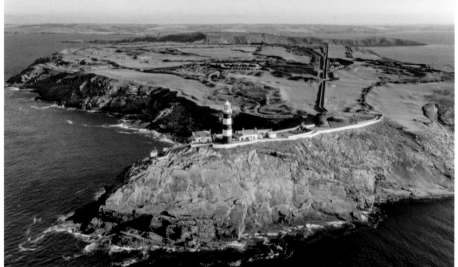

TOP: KINSALE, COUNTY CORK

Situated on the mouth of the River Bandon, 25km south of Cork city, the fishing port of Kinsale is home to a large yachting marina and great restaurants. Famous sights include Charles Fort and the nearby Old Head of Kinsale.

ABOVE: OLD HEAD OF KINSALE, COUNTY CORK

Stretching out into the Atlantic, the Old Head is one of Ireland's most famous coastal landmarks, its lighthouse looking defiantly out to sea. It is the closest point of land to where the *Lusitania* sank in 1915, struck by a German torpedo.

TOP RIGHT: INCHYDONEY, COUNTY CORK

Inchydoney Island, close to Clonakilty, has a splendid, expansive beach, popular with visitors and locals alike. Receiving the international Blue Flag award in 2018, it is one of the most family-friendly beaches in Ireland.

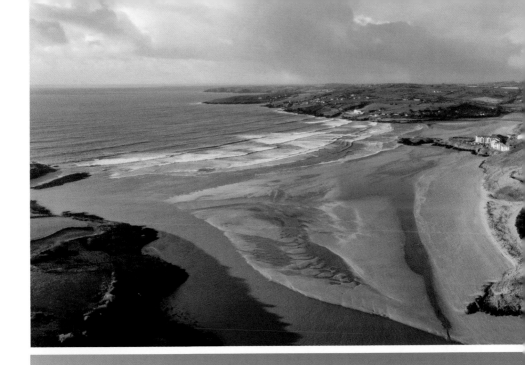

GALLEY HEAD, COUNTY CORK

The gleaming white Galley Head lighthouse stands guard, fifty-three metres above the ocean, as waves crash relentlessly against the headland below. Constructed in 1875, it was, at the time, the most powerful lighthouse in the world.

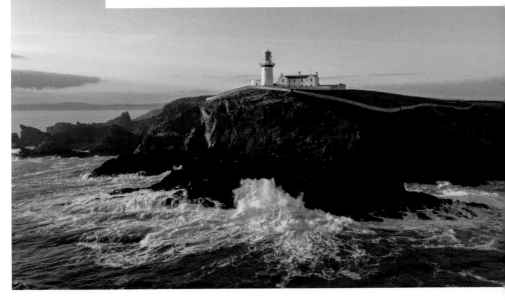

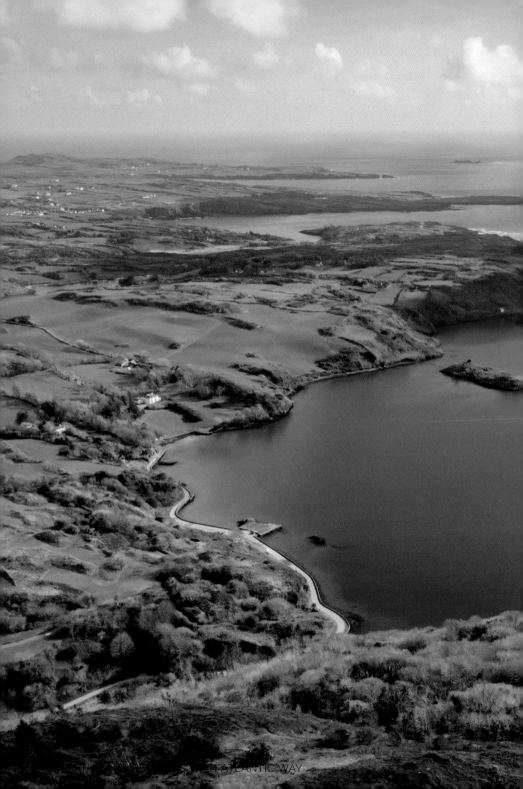

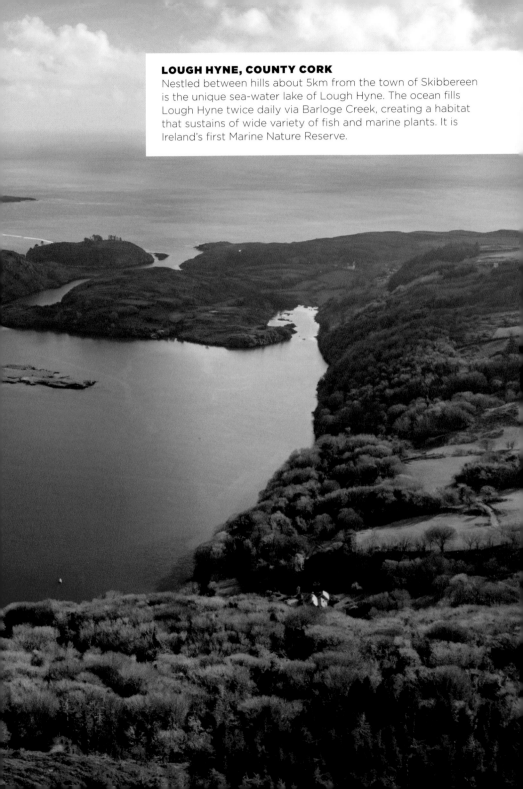

LOUGH HYNE, COUNTY CORK
Nestled between hills about 5km from the town of Skibbereen is the unique sea-water lake of Lough Hyne. The ocean fills Lough Hyne twice daily via Barloge Creek, creating a habitat that sustains of wide variety of fish and marine plants. It is Ireland's first Marine Nature Reserve.

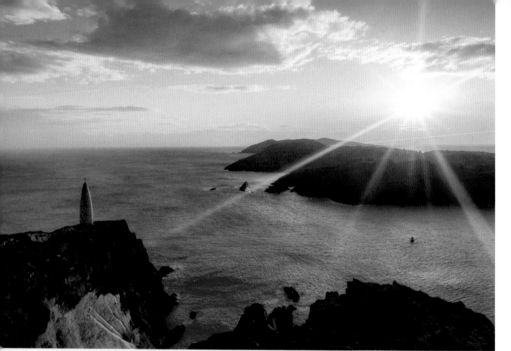

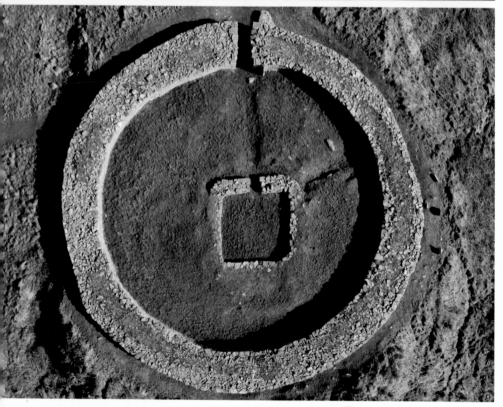

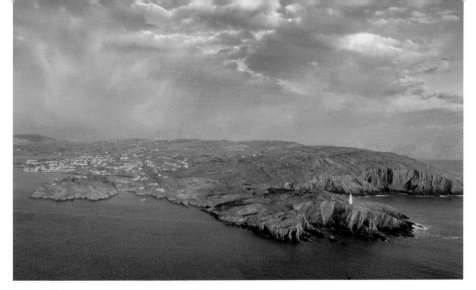

TOP LEFT AND ABOVE: BALTIMORE, COUNTY CORK

A hive of activity during the summer, and a scuba diving base from which to explore shipwrecks of old, Baltimore Harbour is also the embarkation point for trips to Cape Clear and Sherkin Island. The imposing Baltimore beacon, built in 1849, looks out over the harbour.

BOTTOM LEFT:
**** HIDDEN GEM ****
KNOCKDRUM STONE FORT, COUNTY CORK

Further west near Castletownshend lies the ancient Iron Age hilltop fort of Knockdrum, With a diameter of twenty-nine metres and walls three metres thick, it is a truly spectacular place to visit. Slightly off the beaten track, it does not get many visitors.

BELOW: TOE HEAD, COUNTY CORK

Situated on cliffs rising over sixty metres above the sea, the views of the Celtic Sea and Atlantic Ocean here are superb. On a clear day, one can clearly view the entire stretch of coastline back the distant Galley Head.

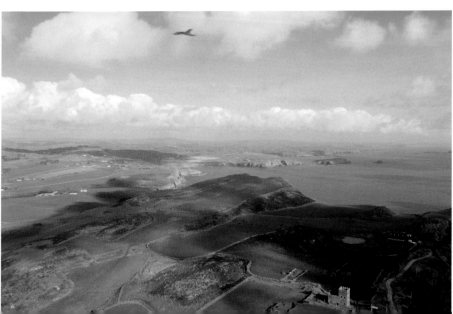

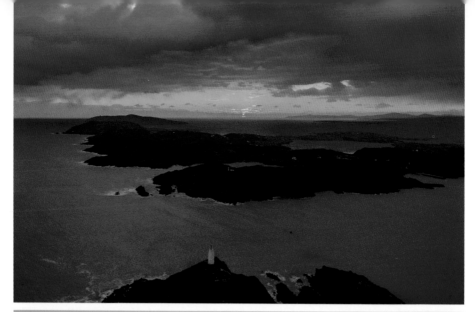

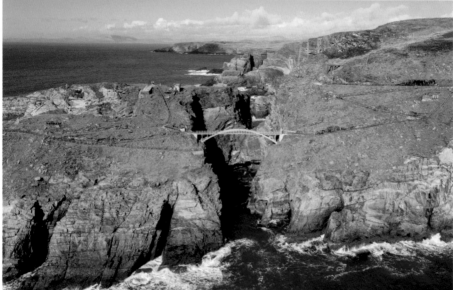

TOP: SHERKIN ISLAND, COUNTY CORK

The sky glows red over Sherkin, ten minutes by ferry from Baltimore. The island measures 5km by 3km and has an average population of 100. Located by the pier is Sherkin's Franciscan Abbey, built in 1460.

ABOVE: MIZEN HEAD, COUNTY CORK

Mizen Head, Ireland's most southwesterly point, is a major tourist attraction. The old signal station here houses a museum where the pioneering efforts of Guglielmo Marconi can be seen.

TOP RIGHT: CAPE CLEAR, COUNTY CORK

13km off the West Cork coast, Cape Clear's wild, unspoilt beauty makes it a prominent location for bird watching, and for spotting whales, dolphins, sharks and leatherback turtles.

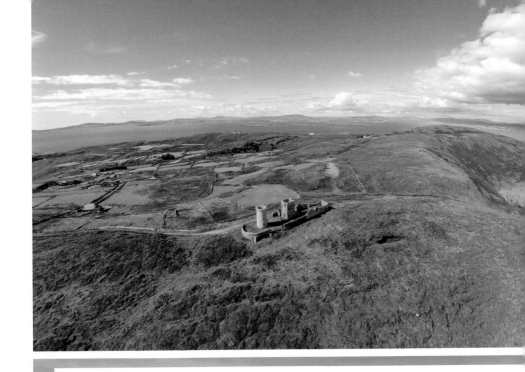

CROOKHAVEN HARBOUR, COUNTY CORK

Facing west over the sheltered Crookhaven Harbour. Crookhaven village has a history as the first and last port of call for ships going between Northern European ports and America. The sheltered harbour is as useful as it is picturesque.

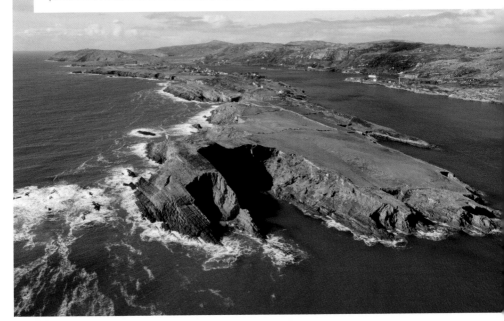

THREE CASTLE HEAD, COUNTY CORK

Perched upon dramatic 100-metre cliffs lie the thirteenth-century ruins of Dunlough Castle. Remote and accessible only by foot through farmland, intrepid visitors are greeted with stunning vistas and the historical ruins.

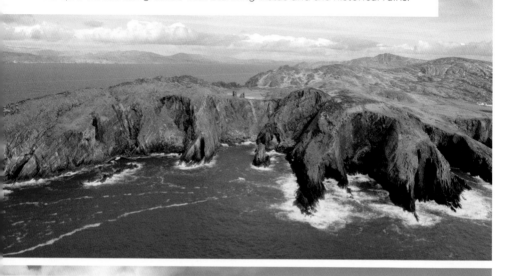

GARINISH ISLAND, COUNTY CORK

Known for its micro climate, beautiful walks and stunning plant specimens, Garinish Island makes for a unique and rewarding trip within the stunning surrounds of Glengariff Harbour. It is open to visitors from April to September.

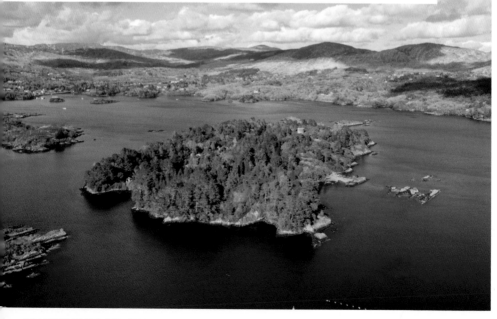

** HIDDEN GEM ** SHEEP'S HEAD, COUNTY CORK

Situated between Bantry Bay and Dunmanus Bay, this stunning and remote peninsula is a hiker's paradise, boasting stunning views in an unspoilt natural landscape. Featuring an 88km walking trail, it was named as a European Destination of Excellence.

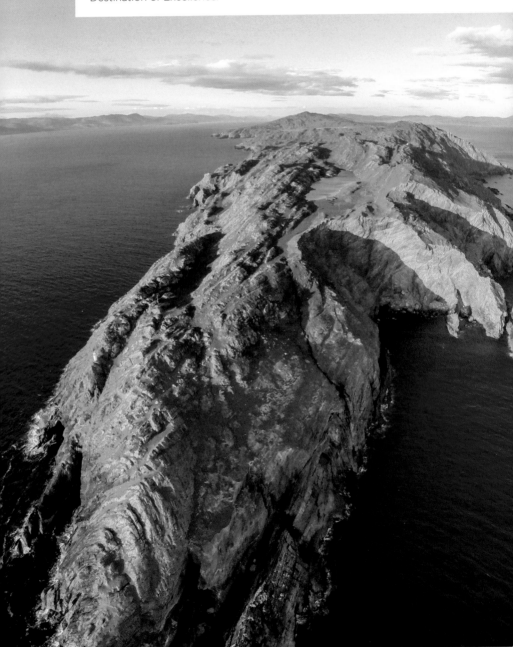

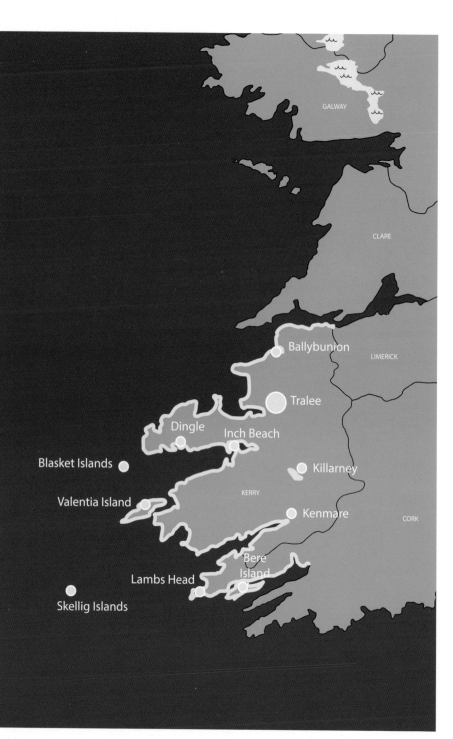

GALWAY

CLARE

LIMERICK

Ballybunion

Tralee

Dingle

Inch Beach

Blasket Islands

Killarney

KERRY

Valentia Island

Kenmare

CORK

Bere
Island

Lambs Head

Skellig Islands

SOUTHERN PENINSULAS

Featuring dramatic mountain ranges and island ruins, the western edge of Europe, from West Cork to Kerry

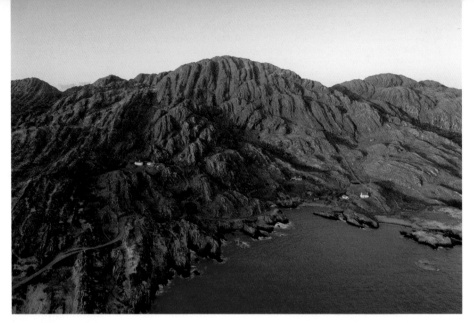

ABOVE: ALLIHIES COASTAL ROAD, COUNTY CORK

The road through the mountainous coastline of Beara is truly breathtaking, especially if you are blessed with good weather. The unique landscape, the crystal blue waters and the salty warm air make for a most memorable trip.

BELOW: HUNGRY HILL, COUNTY CORK

Overlooking Bere Island is Hungry Hill – one of the most distinctive of the Caha Mountains in the southwest. There are numerous routes to the summit from Healy Pass, suitable both for rock climbers and hikers.

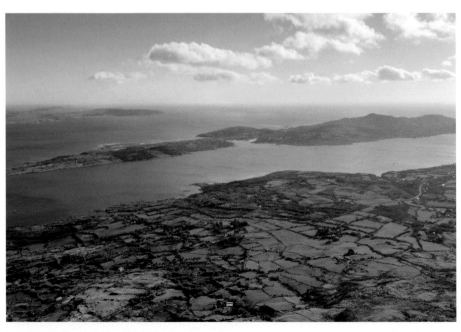

BERE ISLAND, COUNTY CORK

Accessible via car ferry from Castletownbere, Bere Island sits majestically at the entrance to Bantry Bay. The island offers breathtaking scenery and is a paradise for cycling, walking, fishing and yachting.

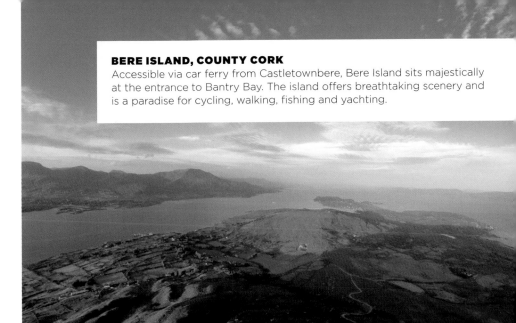

ALLIHIES VILLAGE AND COPPERMINE, COUNTY CORK

The western edge of Beara has been a site of copper mining since the Bronze Age up until the closure of the mining operations in 1884. A museum dedicated to the area's mining history was opened in 2007.

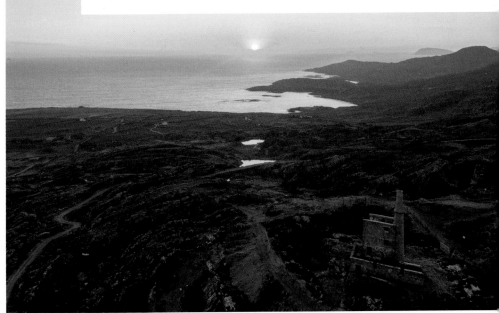

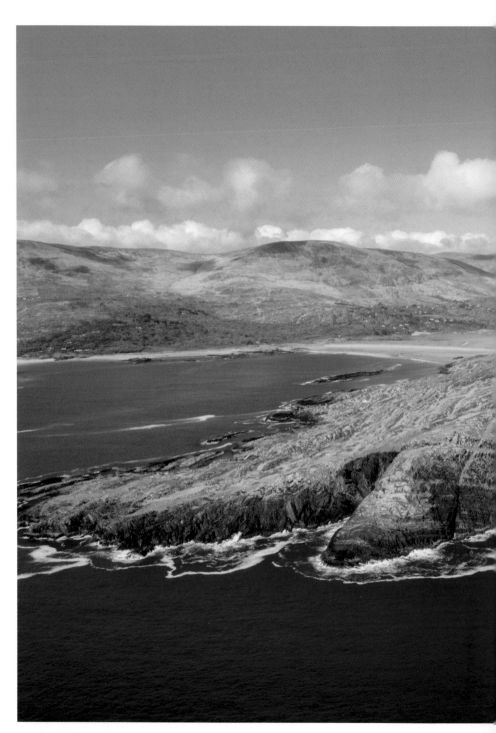

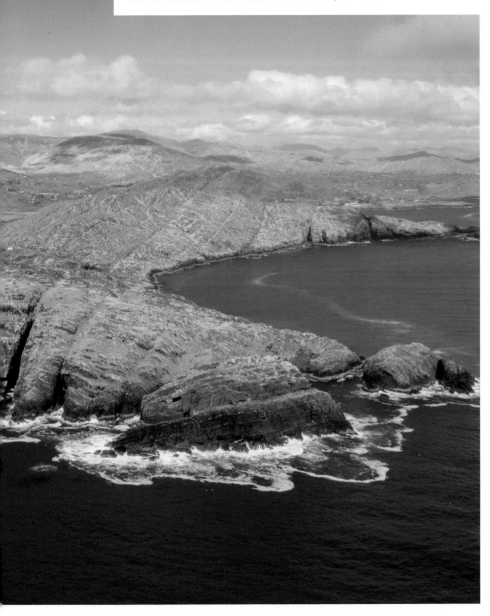

LAMBS'S HEAD, COUNTY KERRY

Stretching out into the Atlantic is the rocky Lamb's Head, and a small natural harbour lies isolated near its outermost point, where the road ends. A place to discover the rugged and sometimes wild side of Ireland's coastline, it makes for a perfect afternoon stroll.

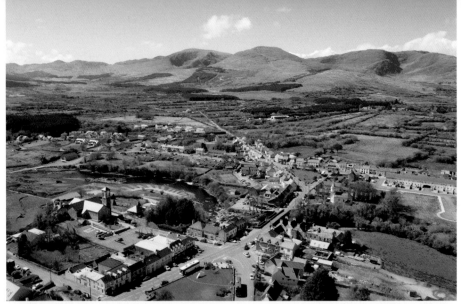

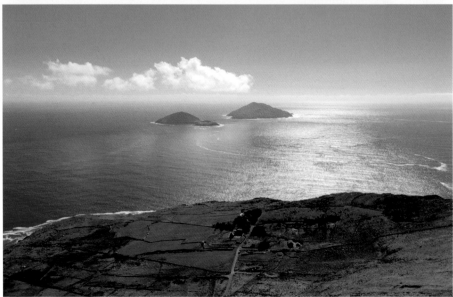

TOP: SNEEM, COUNTY KERRY

One of Ireland's most picturesque villages, situated between Kenmare and Waterville on the Ring of Kerry, Sneem boasts pubs, restaurants and craft shops, painted in an array of beautiful colours.

ABOVE: COOMAKESTA PASS, COUNTY KERRY

The road from Caherdaniel rises to 215 metres above sea level, and treats us panoramic views over Deenish and Scariff Island, Abbey Island and Kenmare River.

TOP RIGHT: BALLINSKELLIGS BEACH, COUNTY KERRY

Ideal for walking as well as watersports. Ballinskelligs Castle (or McCarthy Mór Castle), standing on the beach itself, guarded against pirates in the 15th and 16th centuries.

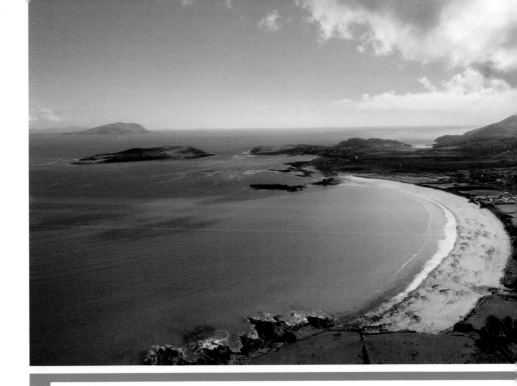

COOMANASPIC PASS, COUNTY KERRY

The drive from Ballinskelligs to Commanaspic Pass is quite simply stunning. At this elevation you can view both sides of the Iveragh Peninsula, from Portmagee village in the north to Bolus Mountain in the south.

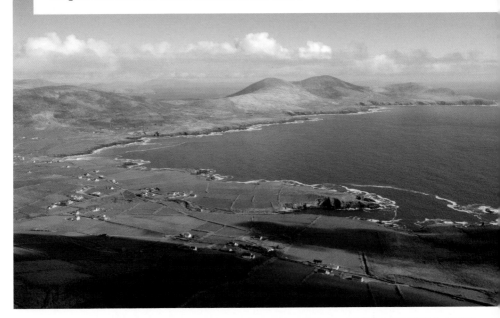

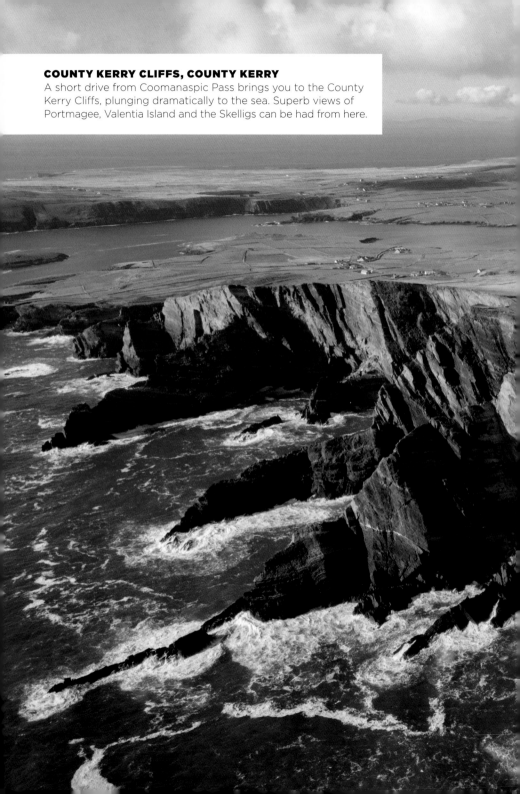

COUNTY KERRY CLIFFS, COUNTY KERRY
A short drive from Coomanaspic Pass brings you to the County Kerry Cliffs, plunging dramatically to the sea. Superb views of Portmagee, Valentia Island and the Skelligs can be had from here.

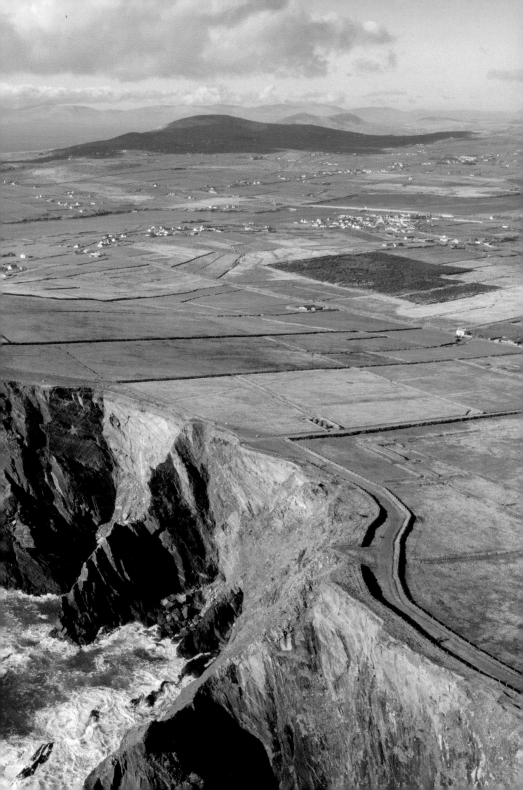

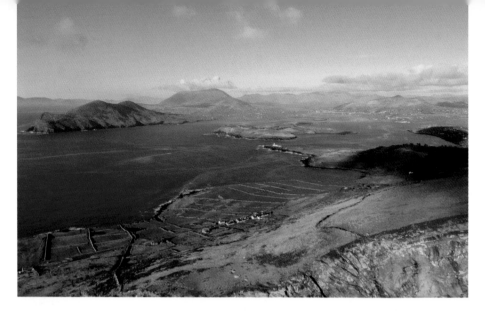

ABOVE: GEOKAUN MOUNTAIN, COUNTY KERRY

The highest point on Valentia, an island of great beauty and contrast, is Geokaun Mountain. With spectacular views in every direction, the mountain is accessible on foot or by car, and the nearby Fogher Cliffs can also be viewed here.

BELOW: BRAY HEAD, COUNTY KERRY

View of Bray Head, Valentia Island. Joined to the mainland by bridge via Portmagee, Valentia Island was the eastern part of the first viable transatlantic telegraph cable, connecting across the ocean to Newfoundland, Canada.

RIGHT: SKELLIG ISLANDS, COUNTY KERRY

There really is no place on Earth like the Skelligs. Many thousands of birds live here, and a 6th century monastery stands atop the summit of Skellig Michael, 180 metres above sea level, where monks lived in their tiny beehive cells. Skellig Michael featured in the recent Star Wars movies.

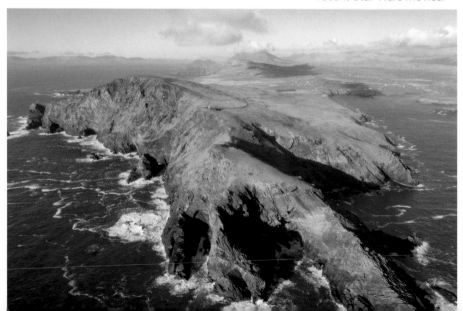

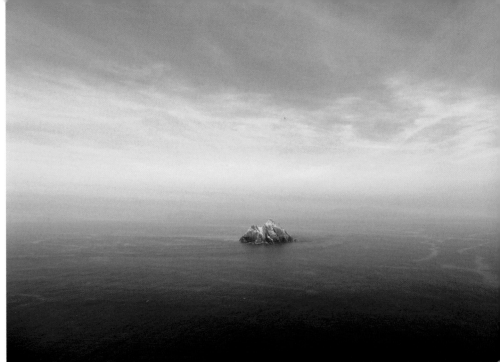

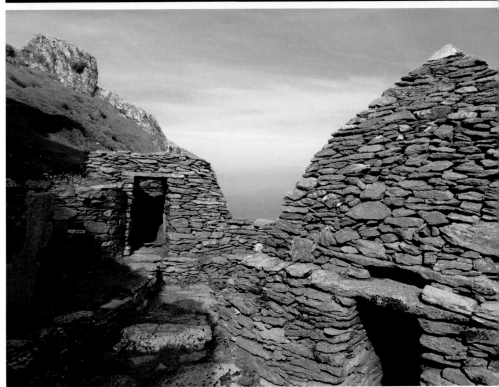

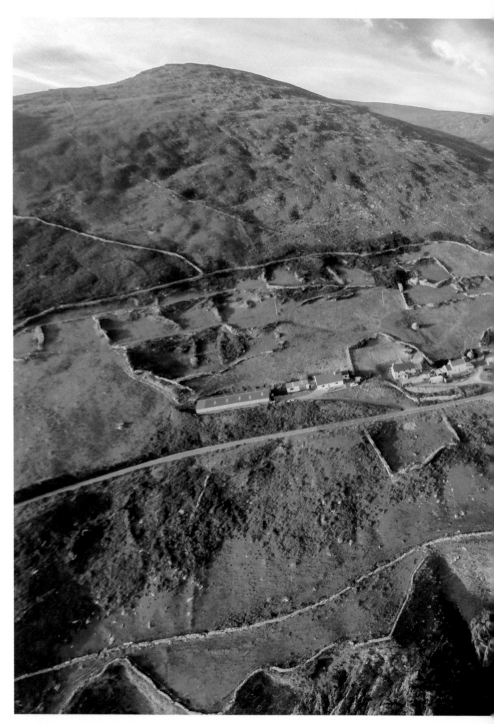

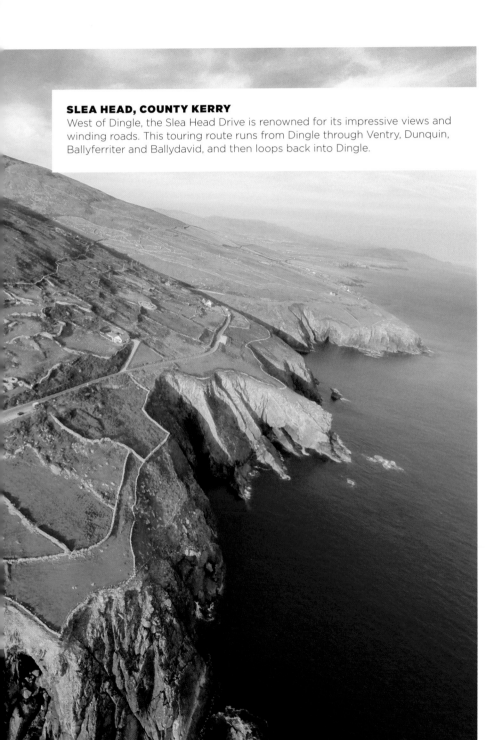

SLEA HEAD, COUNTY KERRY

West of Dingle, the Slea Head Drive is renowned for its impressive views and winding roads. This touring route runs from Dingle through Ventry, Dunquin, Ballyferriter and Ballydavid, and then loops back into Dingle.

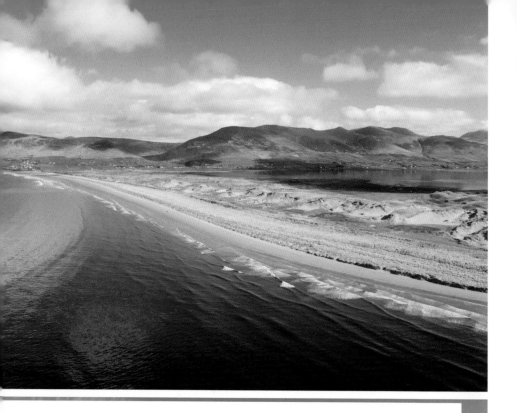

GREAT BLASKET ISLAND, COUNTY KERRY

A visit to this remote and spectacular island, by boat from Dunquin, is truly a must. The island produced a remarkable number of gifted writers, and was populated until 1953. The pristine white sand beach, An Trá Bán, is home to home to up to 1000 seals during the winter months.

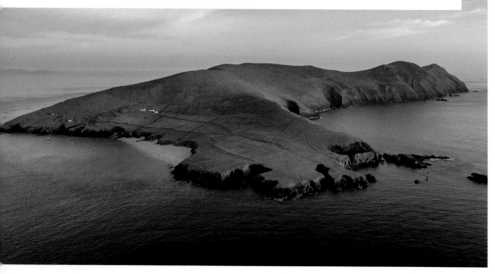

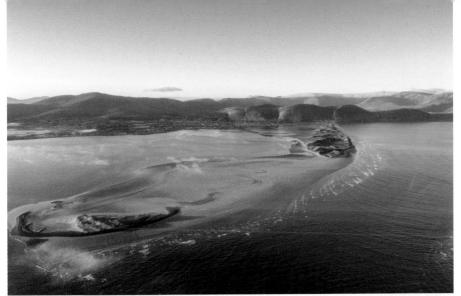

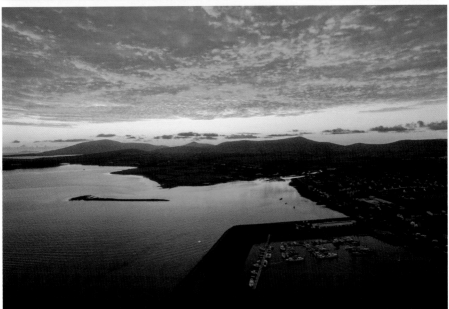

ABOVE LEFT: INCH STRAND, COUNTY KERRY

It is easy to see why this beautiful beach was chosen for filming 'Ryan's Daughter' (1970). Stretching over 5km and backed by expansive sand dunes, it is perfect for windsurfing, kayaking and kite surfing.

TOP: ROSSBEIGH BEACH, COUNTY KERRY

Rossbeigh boasts an impressive 4km stretch of beautiful sandy beach, perfect for an early morning or late evening stroll. The rumble of the waves on the sand is both soothing and invigorating.

ABOVE: DINGLE, COUNTY KERRY

Its stunning setting, vibrant culture and famous seafood make Dingle a must-see town. Dingle's most famous personality, Fungi the Dolphin, has charmed visitors since 1983.

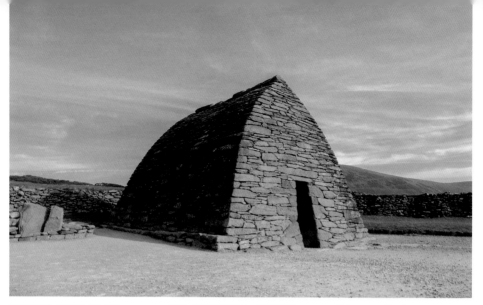

ABOVE: GALLARUS ORATORY, COUNTY KERRY

Near Ballyferriter village stands the iconic Gallarus Oratory chapel. Resembling an upturned boat, its exact age is unknown but it is thought to date from the 11th or 12th century.

BELOW: BEALE STRAND, COUNTY KERRY

At the southern bend of the Shannon Estuary lies the 4km-long Beale Strand. A few wooden ribs of the Thetis, forced on to the shore and broken up by high seas in 1834, can still be seen, poking up out of the sand.

ABOVE RIGHT: BALLYBUNION BEACH, COUNTY KERRY

The seaside resort of Ballybunion in North Kerry is justifiably famous for its spectacular cliff walks and its beautiful sandy beach. Ballybunion is also home to a top-class golf course.

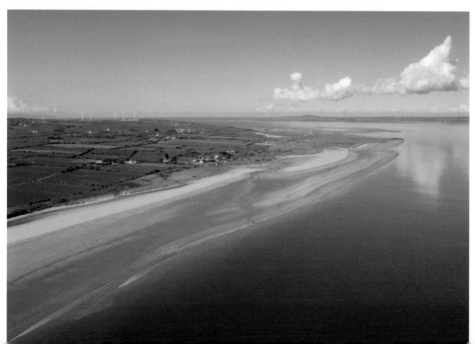

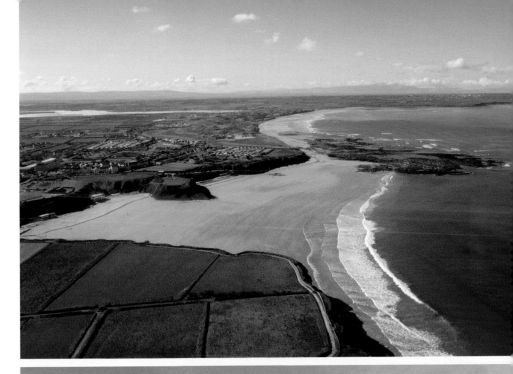

CARRIGAFOYLE CASTLE, COUNTY KERRY

Built in 1490, Carrigafoyle Castle is located on the banks of the Shannon Estuary. During the Second Desmond Rebellion of 1580, the castle was breached after a two-day siege on Palm Sunday, and its Irish and Spanish defenders were massacred.

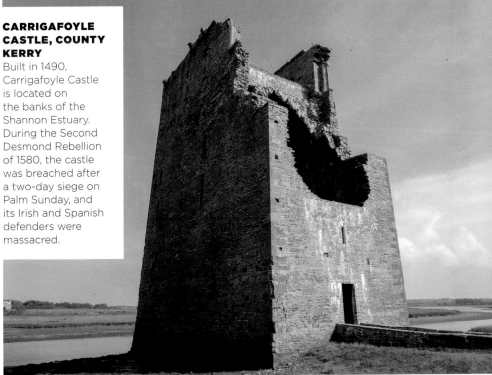

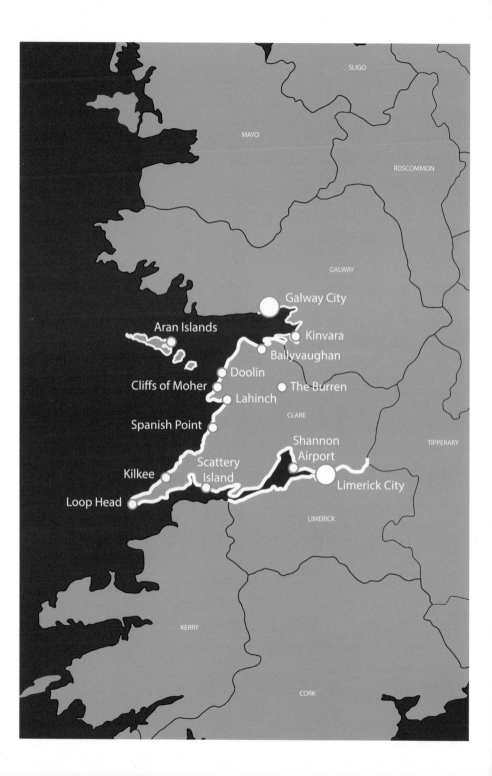

THE CLIFF COAST

Dramatic cliffs and soulful
landscapes from North Kerry
to Clare and Galway

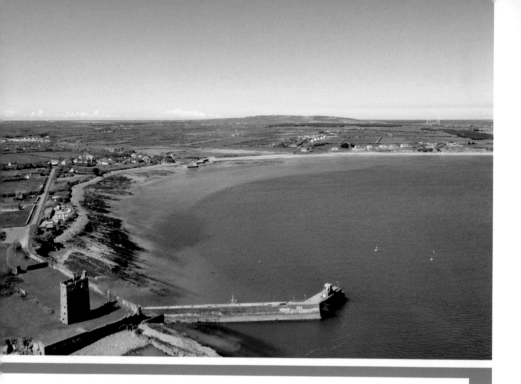

LOOP HEAD, COUNTY CLARE

Situated at the tip of west Clare, this prominent headland features its famous lighthouse, and a climb to the top rewards you with stunning views from Kerry to the Cliffs of Moher. At the very tip of the peninsula, large white letters spelling ÉIRE were placed to let WWII pilots know they were entering neutral airspace.

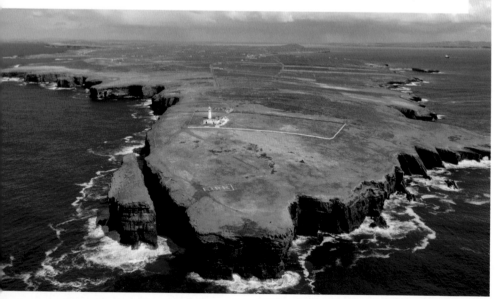

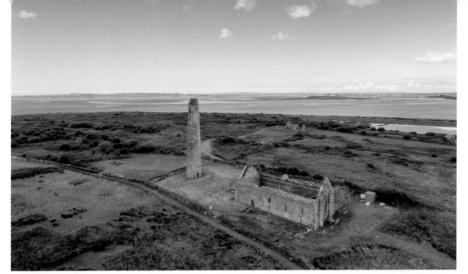

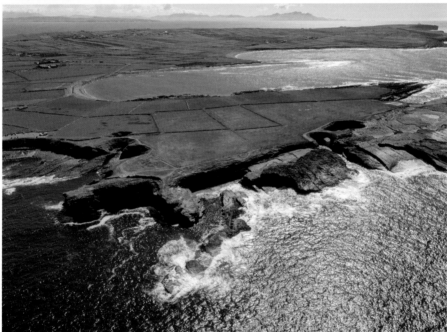

ABOVE LEFT:
CARRIGAHOLT BAY,
COUNTY CLARE
This bay is the first safe harbour for boats travelling up the River Shannon. The five-storey castle near the pier was built in 1480 by the McMahons, chiefs of Loop Head peninsula.

SCATTERY ISLAND,
COUNTY CLARE
Accessible nowadays by ferry from Kilrush, St. Senan founded a monastery here in the 6th century. Remains of this ancient settlement include the impressive round tower, said to be the tallest in Ireland.

BRIDGES OF ROSS,
COUNTY CLARE
Once a trio of spectacular sea arches, just one remains. The site is a also renowned bird watching area, with shearwaters, petrels and skuas passing in late summer, on their way south.

CLIFFS OF MOHER, COUNTY CLARE

Stretching along 8km of coastline and reaching 214 metres at their highest point, the Cliffs of Moher are undoubtedly one of Ireland's best-known natural wonders. The views from the path along the cliff edge are simply breathtaking.

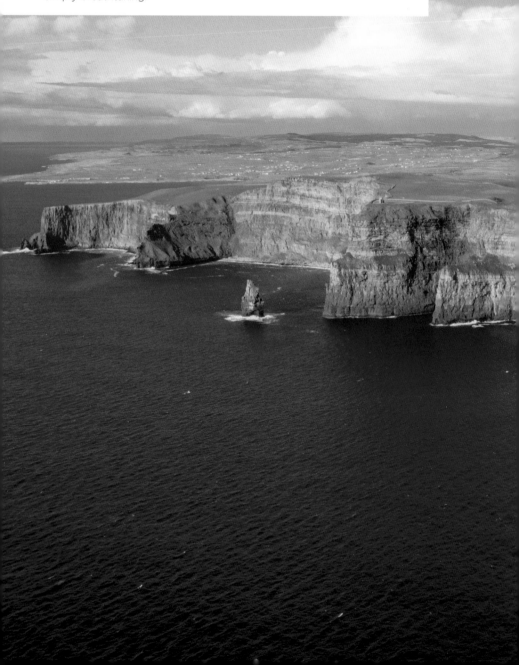

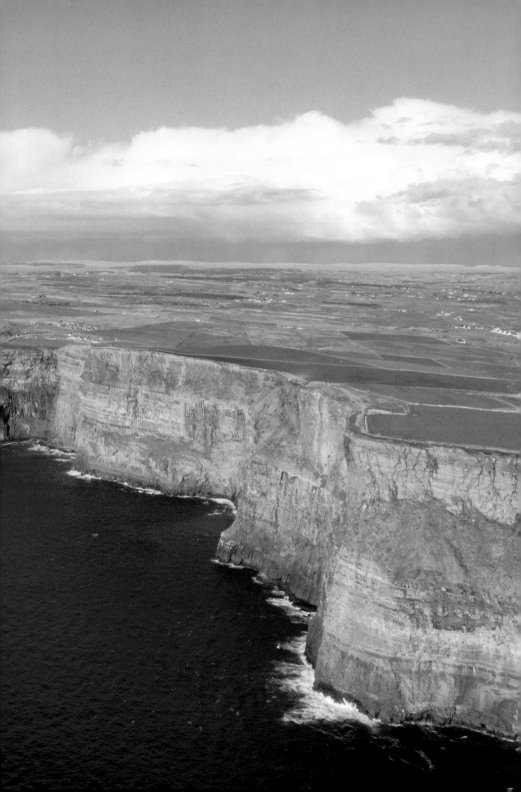

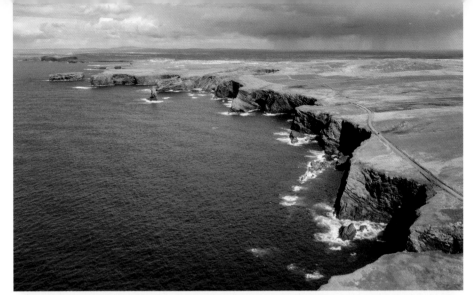

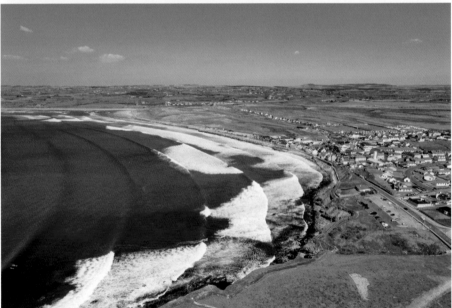

TOP: KILKEE CLIFFS, COUNTY CLARE

An 8km walk starting at the town of Kilkee includes a natural amphitheatre cut into the rock, a blow hole called the Puffing Hole and the stunning Kilkee Cliffs. A less well-known natural treasure.

ABOVE: LAHINCH, COUNTY CLARE

The busy seaside town is known far and wide as a prime surfing spot. Even from the height of the drone camera, one can see the immense waves that make it a surfer's paradise.

BELOW RIGHT: SPANISH POINT, COUNTY CLARE

With a lovely beach and a quality golf course, Spanish Point, also a popular surfing spot, gets its name from the many sailors buried here after the wreck of the Spanish Armada in 1588.

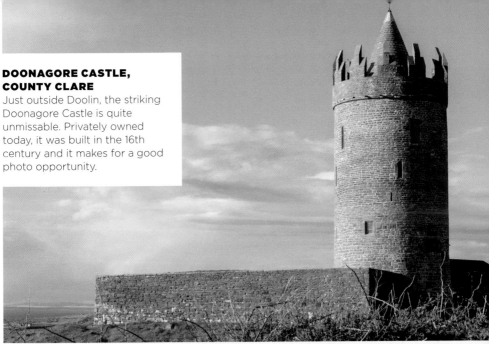

DOONAGORE CASTLE, COUNTY CLARE

Just outside Doolin, the striking Doonagore Castle is quite unmissable. Privately owned today, it was built in the 16th century and it makes for a good photo opportunity.

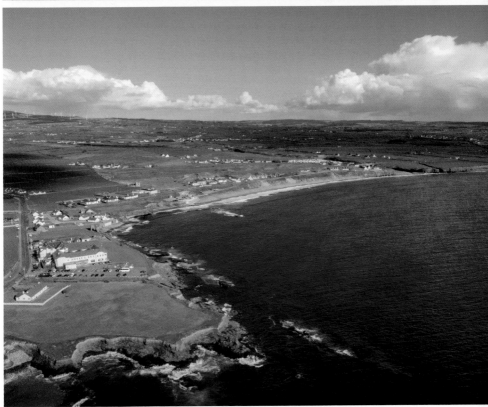

THE BURREN, COUNTY CLARE

Perhaps Ireland's most extraordinary landscape, The Burren is a surreal geological wonder, more like a lunar landscape than an earthly one. The rugged limestone, covering an area of 360km², conceals an immense ecological diversity, with many rare plants and animals. It is designated as an EU Special Area of Conservation.

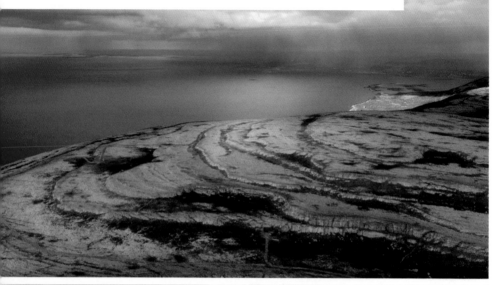

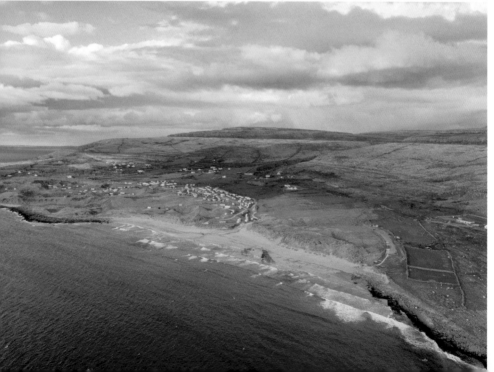

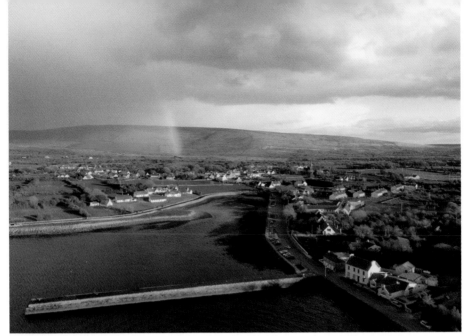

BELOW LEFT: FANORE BEACH, COUNTY CLARE

Between Doolin and Ballyvaughan, surrounded by the unique Burren landscape, the gorgeous and extensive Fanore Beach is home to ancient sand dunes, and the limestone here is full of fossils.

ABOVE: BALLYVAUGHAN, COUNTY CLARE

A rain shower passes over Ballyvaughan, a beautiful village on the southern shore of Galway Bay. The pier is a favoured spot for anglers and the town is a perfect base from which to explore the Burren.

BELOW: DUNGAIRE CASTLE, COUNTY GALWAY

This 16th-century castle stands defiantly at the southeastern shore of Galway Bay just outside the town of Kinvarra. It is open to visitors during the summer months.

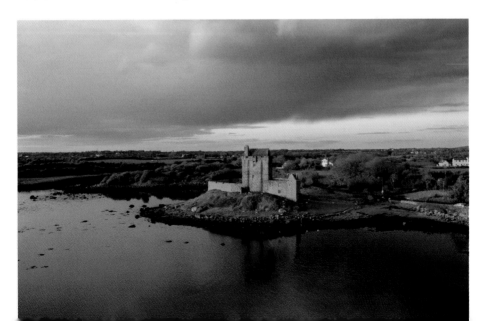

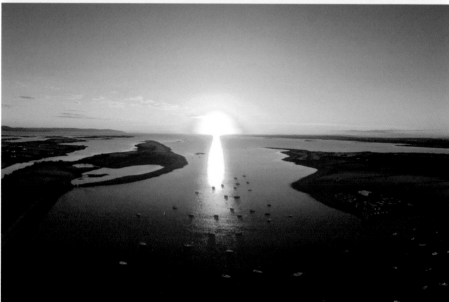

TOP: FLAGGY SHORE, COUNTY CLARE

Located at Finvarra near New Quay, Flaggy Shore is about a kilometre of coastline on one of the most northerly points of the County Clare. It is ideal for walkers with its paved road running along the shore and it sports superb sea views.

ABOVE: RINVILLE PARK, COUNTY GALWAY

Located just outside the village of Oranmore, Rinville Park's gently undulating landscape includes a network of woodland walks and sensational views over Galway Bay. Its serene beauty is ideal for picnicking and walking.

TOP RIGHT: RIVER CORRIB, GALWAY CITY

Galway, the City of the Tribes, is a lively and colourful city, revered as a top destination. With many fantastic restaurants and pubs overflowing with traditional music, is a gateway to the Gaeltacht and Connemara.

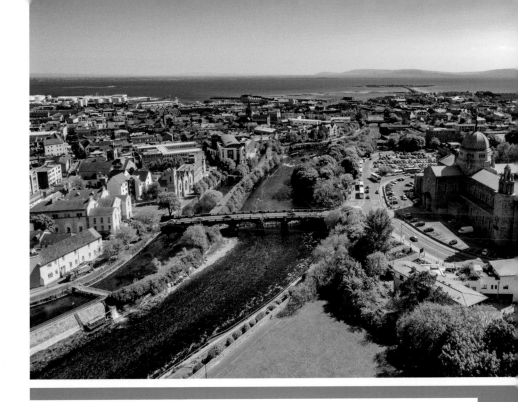

SALTHILL PROMENADE, GALWAY CITY

Known by locals as 'The Prom', Salthill Promenade runs for 2km from the edge of Galway city. There is plenty of seating along its length where you can enjoy spectacular views of Galway Bay and the Aran Islands.

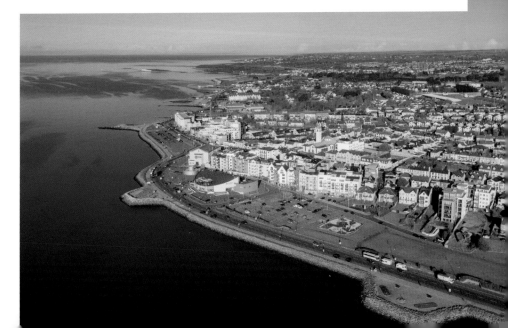

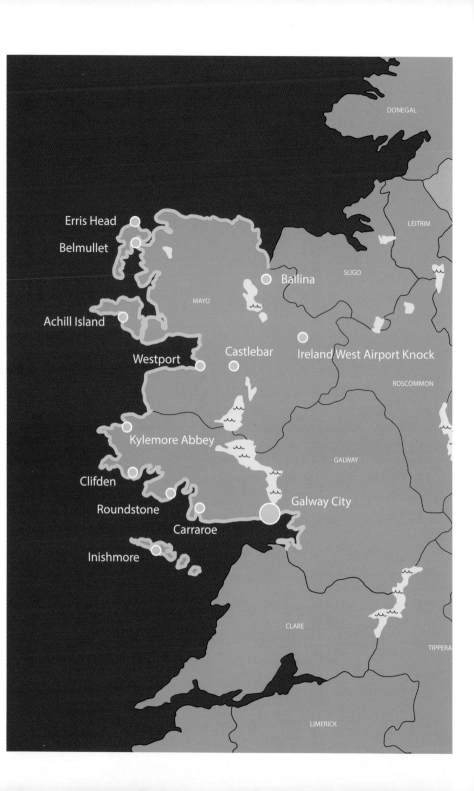

THE BAY COAST

From the dazzling beaches of Galway to the wild and pristine coastline of Mayo

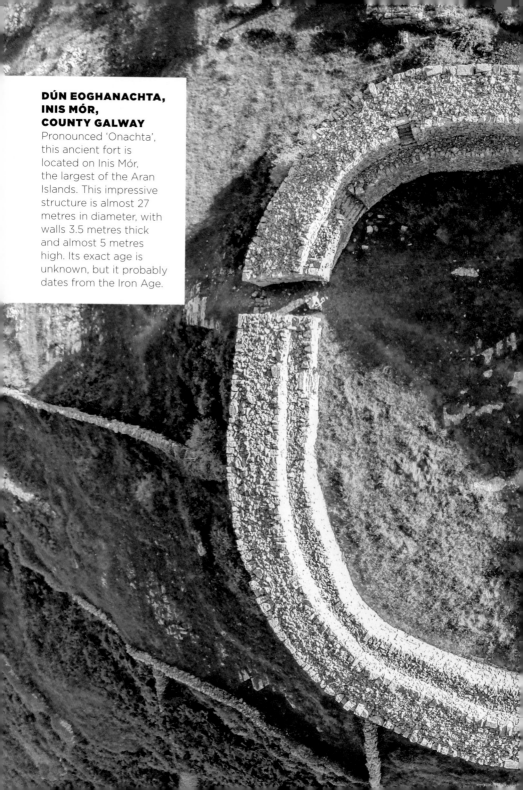

DÚN EOGHANACHTA, INIS MÓR, COUNTY GALWAY

Pronounced 'Onachta', this ancient fort is located on Inis Mór, the largest of the Aran Islands. This impressive structure is almost 27 metres in diameter, with walls 3.5 metres thick and almost 5 metres high. Its exact age is unknown, but it probably dates from the Iron Age.

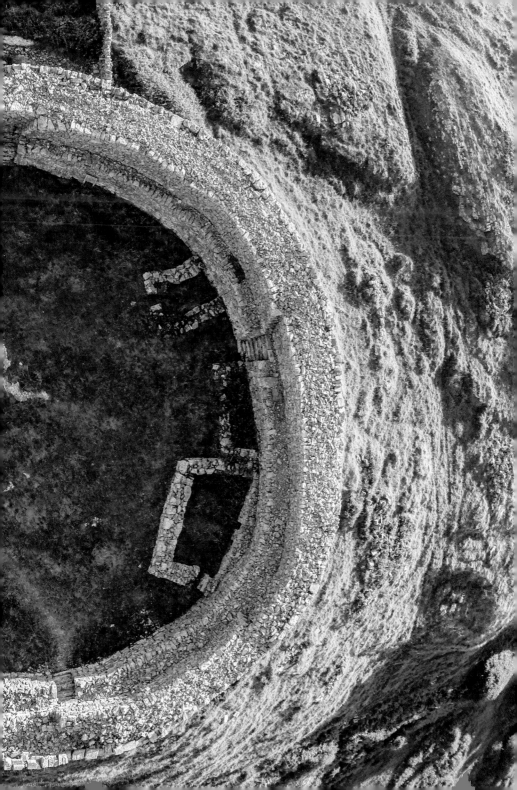

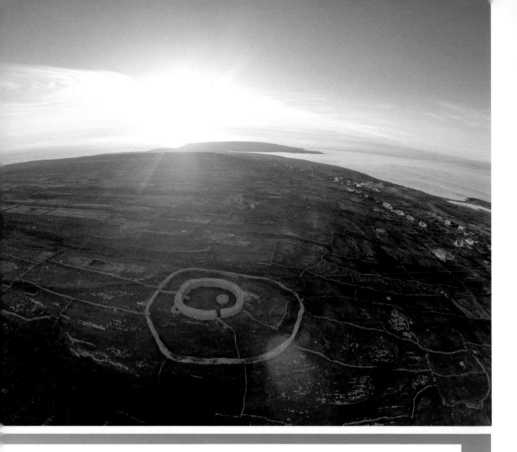

SPIDDAL, COUNTY GALWAY

Located 18km from Galway city, Spiddal's scenery is familiar to viewers of Irish TV's soap drama 'Ros na Rún'. It is home to some lovely traditional pubs and restaurants, a stand-out Gothic church built in the early 20th century, and a sandy beach with views across the bay to the Burren.

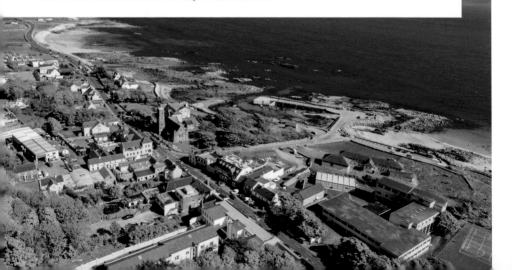

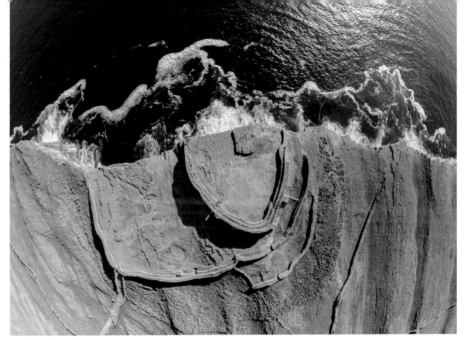

ABOVE LEFT: DÚN EOCHLA, COUNTY GALWAY
Standing at one of the highest points on Inis Mór, this ancient fort is in superb condition. Easily accessible from the main road, it offers great views over the eastern part of the island.

ABOVE: DÚN AONGHASA, COUNTY GALWAY
The largest and best-known of the prehistoric forts on the Aran Islands, spectacularly situated on a cliff edge, Dún Aonghasa is mysterious and breath-taking in equal measure.

BELOW: CORAL BEACH, COUNTY GALWAY
Near Carraroe, in the heart of the Connemara Gaeltacht, Coral Beach, or Trá an Dóilín, is an area of outstanding natural beauty, and an extraordinary place for a swim.

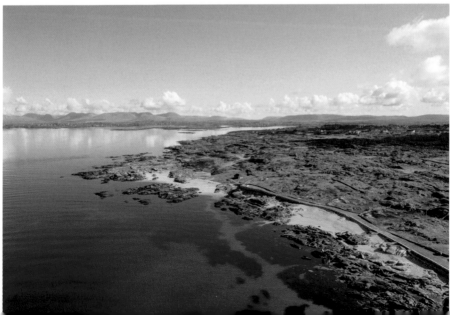

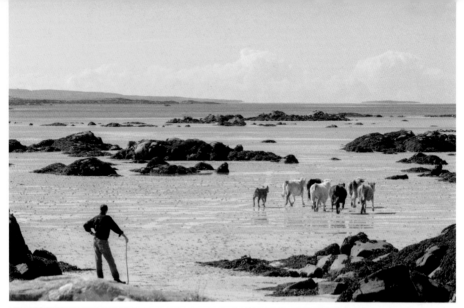

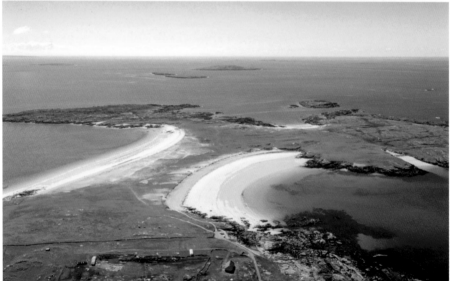

TOP: FINISH ISLAND, COUNTY GALWAY

The best thing to do on Finish Island is to simply relax and soak in the quiet atmosphere. Sunny weather highlights the gorgeous sand and clear blue water. This is an ideal place to laze about and disconnect from the world.

ABOVE: GURTEEN AND DOG'S BAY, COUNTY GALWAY

Three kilometres from Roundstone are two of the finest beaches in Ireland – Gurteen and Dog's Bay. Facing each other back-to-back, their white sands and turquoise water make them an absolute must see.

ABOVE RIGHT: ROUNDSTONE, COUNTY GALWAY

Roundstone's quiet seaside charm and colourful character make it a great place to stop for a bite to eat or to relax with a pint. This may well be one of the most pleasant towns in all of Connemara.

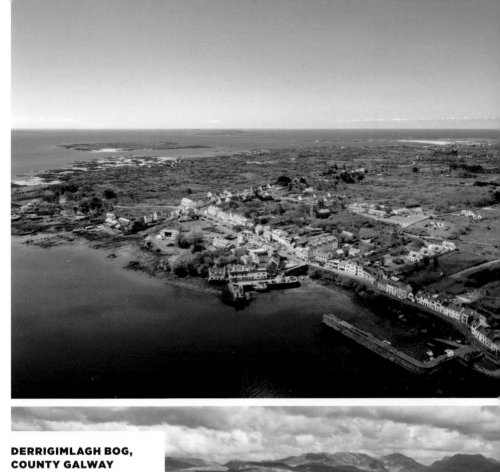

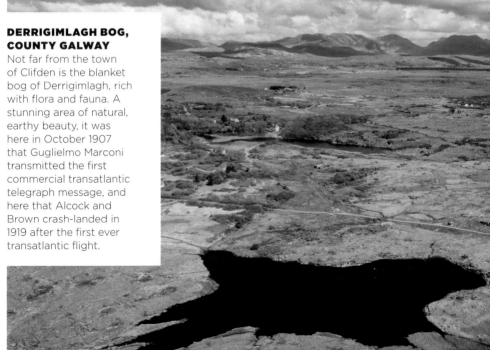

DERRIGIMLAGH BOG, COUNTY GALWAY

Not far from the town of Clifden is the blanket bog of Derrigimlagh, rich with flora and fauna. A stunning area of natural, earthy beauty, it was here in October 1907 that Guglielmo Marconi transmitted the first commercial transatlantic telegraph message, and here that Alcock and Brown crash-landed in 1919 after the first ever transatlantic flight.

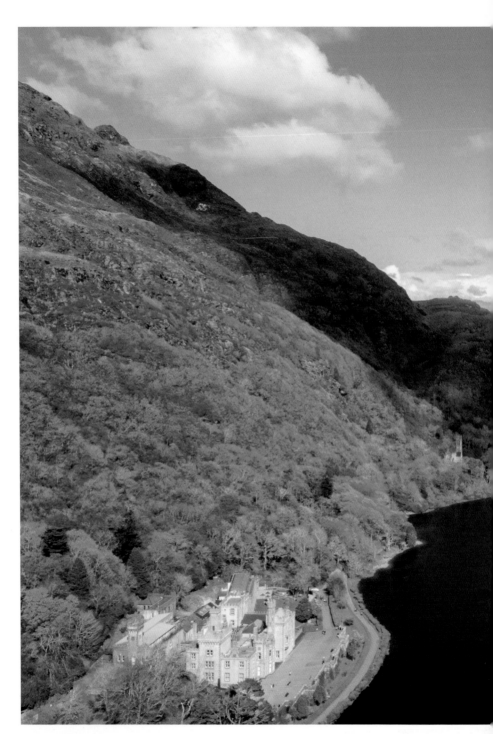

KYLEMORE ABBEY, COUNTY GALWAY

A must see on any visit to Connemara, Kylemore Abbey, with its 6-acre Victorian walled garden, is set amid an enchanting landscape, overlooking Connemara National Park. It features peaceful woodland walks, impressive Gothic architecture and spectacular gardens. Built in the late 1800s, it is in the care of the Benedictine Community since 1920.

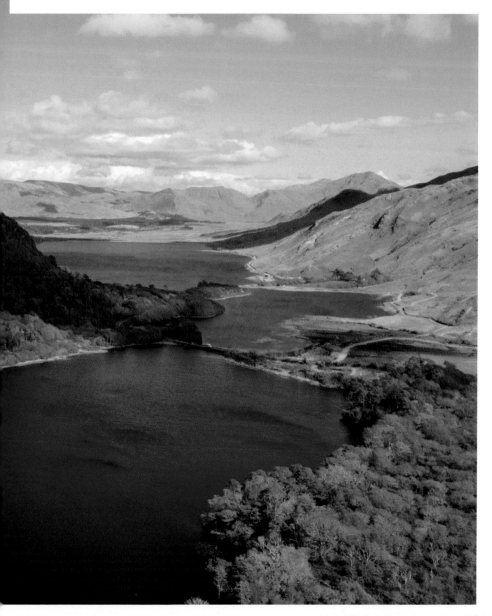

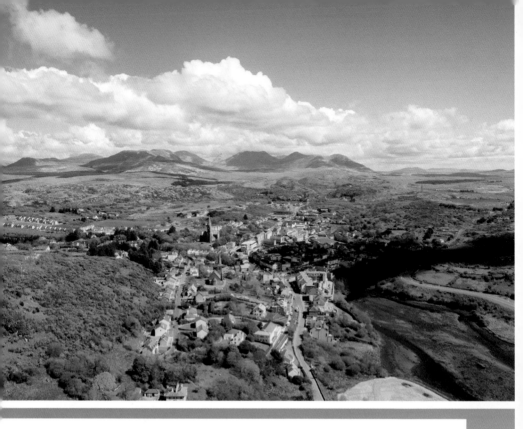

SKY ROAD, COUNTY GALWAY
Coming from Clifden, the steep ascent and exhilarating views of the Connemara coastline is what makes the Sky Road such a thrill, for cyclists and motorists alike. It's also an ideal spot to witness a gorgeous Atlantic sunset.

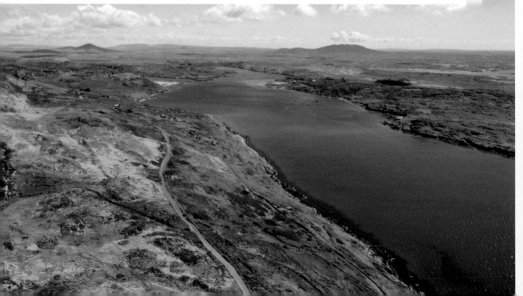

ABOVE LEFT: CLIFDEN, COUNTY GALWAY

Nestled between the Twelve Bens Mountains and the ocean is the picturesque town of Clifden. With its many cafes, bars and shops, Clifden is a great base to explore Connemara from.

ABOVE: OMEY ISLAND, COUNTY GALWAY

Accessible by car across a broad, sandy beach at low tide, Omey Island is a popular place for walkers, with its fantastic scenery and varied wildlife and birds. It's also a great spot to explore on horseback.

BELOW: RENVYLE BEACH, COUNTY GALWAY

Commanding stunning views to Crump and its neighbouring islands off the Renvyle Peninsula, this is a place of unique and unforgettable beauty, a great spot for a picnic or a swim.

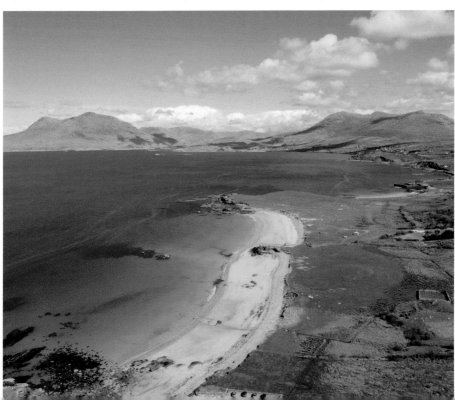

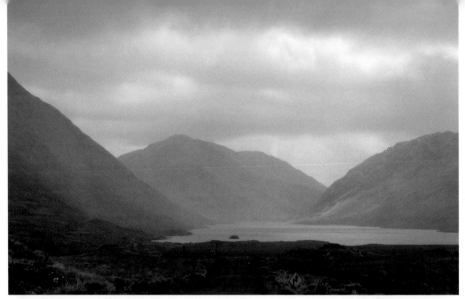

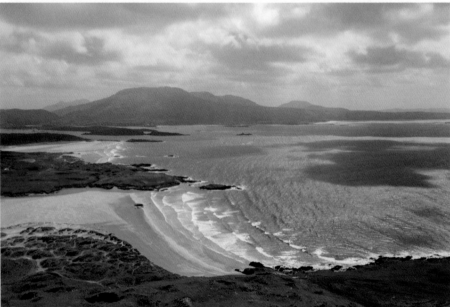

TOP: DOOLOUGH VALLEY, COUNTY MAYO
The mist clears from a lonely road at Doolough Valley. A plain stone cross is engraved with the words 'Doolough Tragedy 1849', a poignant reminder of the suffering of many here during the Great Famine.

ABOVE: SILVER STRAND, COUNTY MAYO
Located north of the mouth of Killary Harbour, at the foothills of Mweelrea Mountain, lies the stunning sandy beach of Silver Strand, commanding panoramic views across to Connemara.

BELOW RIGHT: CARROWNISKEY BEACH, COUNTY MAYO
This 4km-long beach, just a few kilometres from the town of Louisburgh, is a popular spot for surfers, with its mighty, rolling waves. The sunsets here are also stunning,

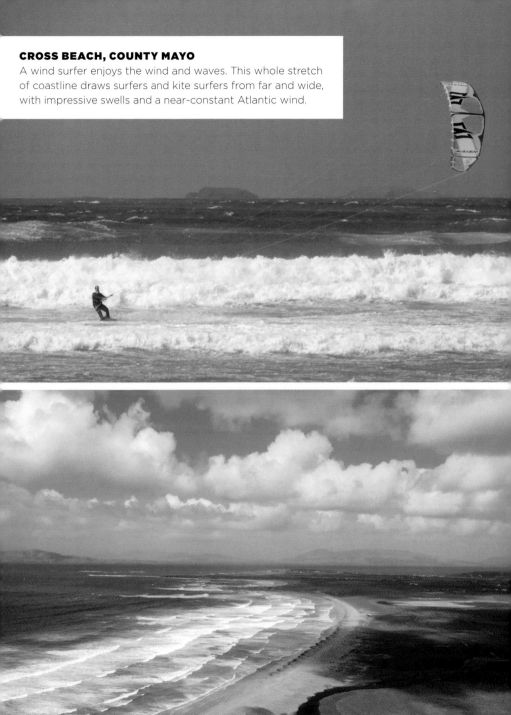

CROSS BEACH, COUNTY MAYO
A wind surfer enjoys the wind and waves. This whole stretch of coastline draws surfers and kite surfers from far and wide, with impressive swells and a near-constant Atlantic wind.

CLEW BAY, COUNTY MAYO

With Croagh Patrick to the south, the Nephin Mountains to the north, and 365 islands in between, Clew Bay is perhaps the most spectacular bay on the island of Ireland. It is also famed as the home of the 'pirate queen' Granuaile.

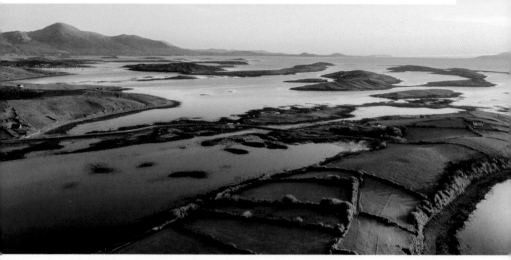

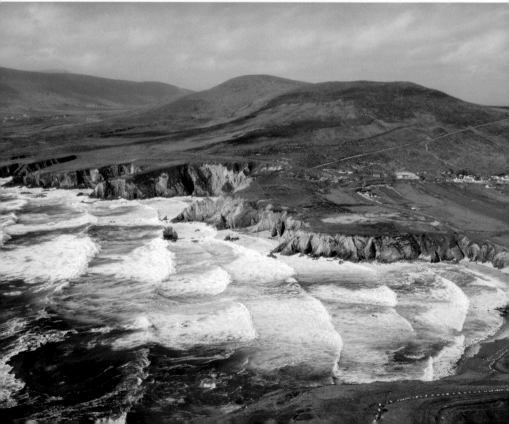

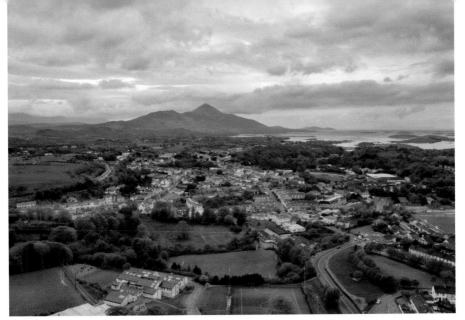

BELOW LEFT: ASHLEAM BAY, COUNTY MAYO

Though the mountains are frequently beset with fog (itself a fine sight), Ashleam Bay on Achill Island reveals its full and incomparable beauty on a clear day. It is the perfect spot to appreciate the power of the Atlantic Ocean as it sweeps ashore.

ABOVE: WESTPORT, COUNTY MAYO

Backed by the imposing Croagh Patrick, and with magnificent views of Clew Bay, Westport simply oozes charm. With enough shops, restaurants and activities to keep a visitor occupied for days, Westport is a must-see town.

BELOW: CLAGGAN MOUNTAIN COASTAL TRAIL, COUNTY MAYO

Situated about 8km south of the Ballycroy National Park, the Claggan Mountain Coastal Trail features a 2km boardwalk route along the bay, with amazing views of the Claggan and Owenduff Mountains.

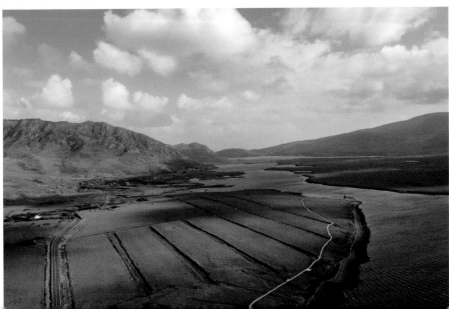

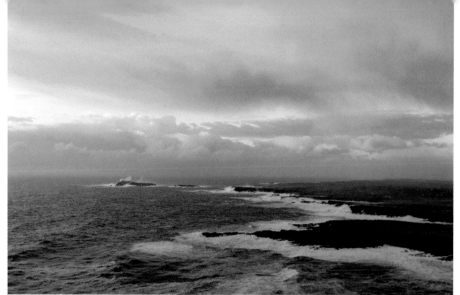

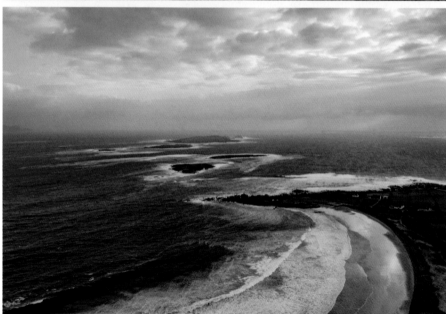

TOP: ANNAGH HEAD, COUNTY MAYO

Looking north toward the storm-battered Eagle Island from Annagh Head. The oldest rocks in Ireland can be found here, dating from 1.7 billion years ago. This is a place of profound and timeless beauty.

ABOVE: FALLMORE, COUNTY MAYO

At the south of the Mullet Peninsula, near Blacksod Bay, Fallmore's small beach has great views across to Achill. Nearby is Deirbhille's Twist – a spiral sculpture of standing boulders.

BELOW RIGHT: ERRIS HEAD, COUNTY MAYO

Erris Head, on the northern tip of the Mullet Peninsula, features a looped walk over dramatic rocky cliffs, with unobstructed views of the Atlantic Ocean.

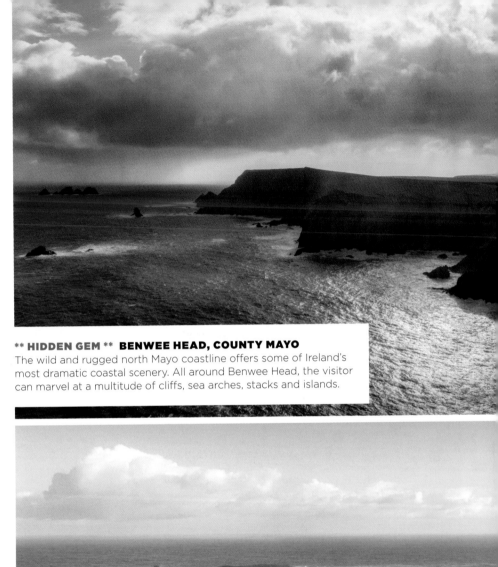

** HIDDEN GEM ** BENWEE HEAD, COUNTY MAYO

The wild and rugged north Mayo coastline offers some of Ireland's most dramatic coastal scenery. All around Benwee Head, the visitor can marvel at a multitude of cliffs, sea arches, stacks and islands.

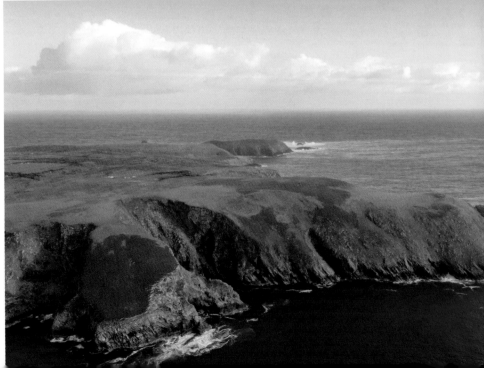

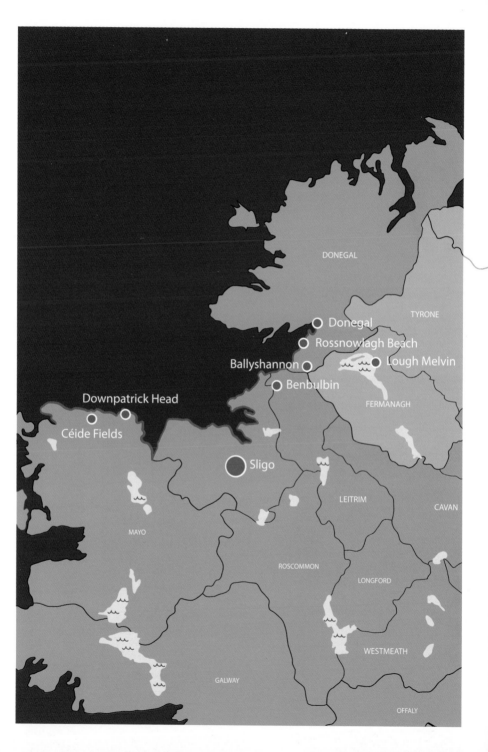

DONEGAL

TYRONE

○ Donegal

○ Rossnowlagh Beach

Ballyshannon ○ ● Lough Melvin

○ Benbulbin

FERMANAGH

Downpatrick Head

○ Céide Fields

○ Sligo

LEITRIM

CAVAN

MAYO

ROSCOMMON

LONGFORD

WESTMEATH

GALWAY

OFFALY

THE SURF COAST

Encompassing north Mayo,
Sligo and south Donegal,
where glorious beaches await

DOWNPATRICK HEAD, COUNTY MAYO

The 40m sea stack known as Dún Briste reveals millions of years of layered sediment, and serves to remind us that even the land itself will succumb to the ocean's power. Ruins of a church, cross and holy well mark an early church founded by St. Patrick himself.

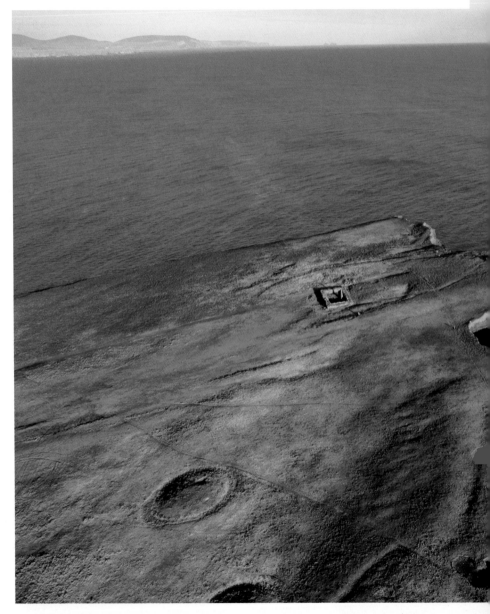

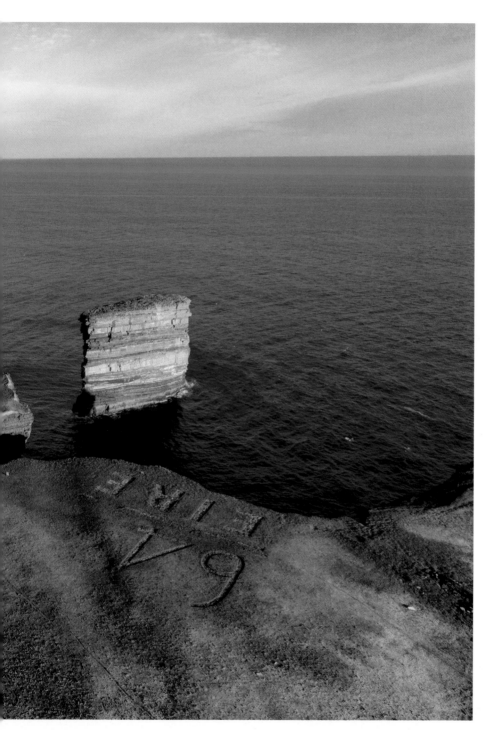

BALLINA QUAY, COUNTY MAYO

Ballina Quay lies on the eastern bank of the Moy River, and is a focal point for the area's small boats. A striking feature is the remains of the SS Creteboom, a concrete shipwreck that lies between Ballina Quay and Belleek Woods.

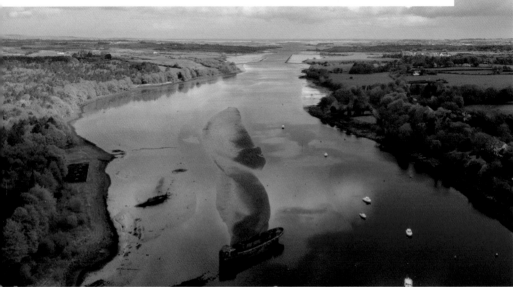

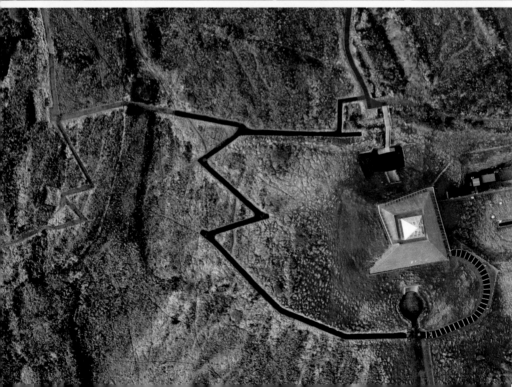

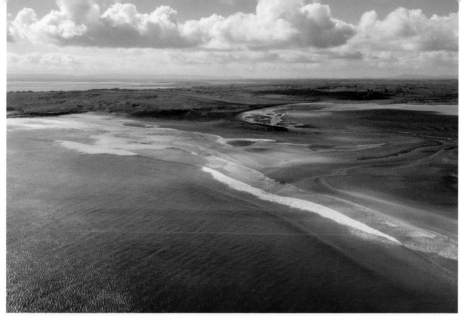

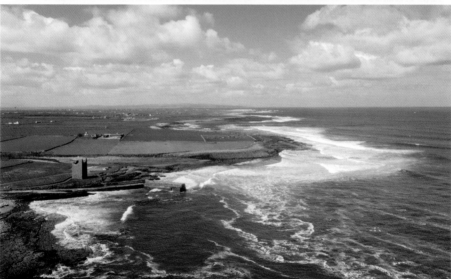

BELOW LEFT: THE CÉIDE FIELDS, COUNTY MAYO

The Céide Fields represent the most extensive Stone Age archaeological site in the world. The 1500-hectare site is comprised of field systems, stone walls and tombs dating from 5,000 years ago.

TOP: LACKAN STRAND, COUNTY MAYO

A vast expanse of golden sand, measuring almost 2km long by 2km wide, Lackan Strand glows red with the setting sun. It can easily count itself among Ireland's most beautiful sights.

ABOVE: EASKEY BEACH, COUNTY SLIGO

Easkey is an internationally renowned surfing destination, with scenic views and wonderful walks. O'Dowd's Castle, dating from 1207, stands as a sentinel over the scene.

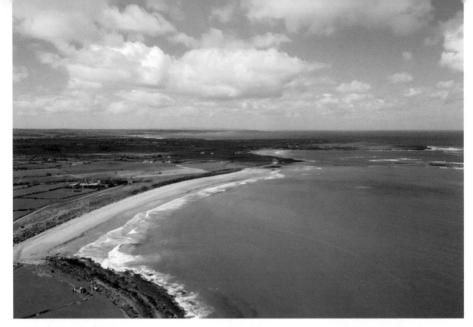

ABOVE: DUNMORAN BEACH, COUNTY SLIGO

14km east of Easkey, Dunmoran Beach shares its stretch of coast with the picturesque fishing harbour of Aughris. A peaceful spot, it is ideal for walks while taking in the stunning north Atlantic views.

BELOW: BENBULBIN, COUNTY SLIGO

Benbulbin was originally part of a large plateau, and was shaped into its distinctive present form during the last ice age. This is Yeats country, the inspiration for writer and poet W.B. Yeats.

ABOVE RIGHT: ROSSES POINT, COUNTY SLIGO

A popular seaside resort, with splendid views of Sligo bay to the west and the Dartry mountain range to the east. From the nearby yacht club, one can see across to Coney Island and Blackrock lighthouse.

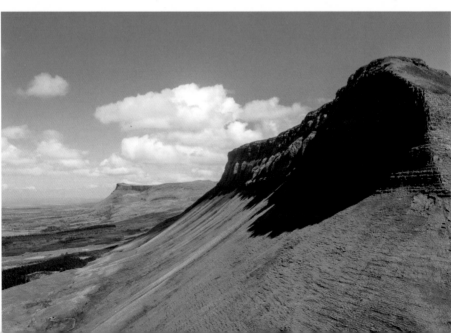

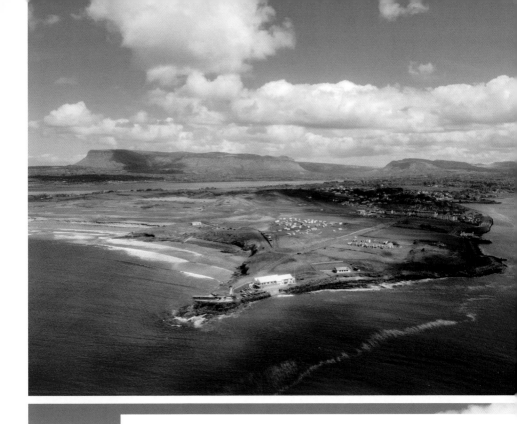

** HIDDEN GEM ** STREEDAGH POINT, COUNTY SLIGO

From Streedagh Point, a fine, 3km-long beach extends on a sandbar to an area known as O'Connor's Island, popular with windsurfers and walkers alike for its pleasant views and salty atmosphere.

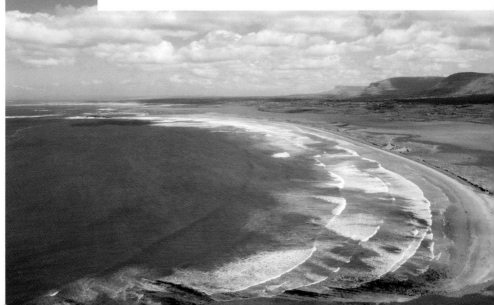

LOUGH MELVIN, COUNTY LEITRIM
Though County Leitrim only has 4km of Atlantic coastline, it is not to be overlooked. The stunning and internationally renowned Lough Melvin, near Kinlough town, is an unspoilt lake, famous for its unique diversity of fish.

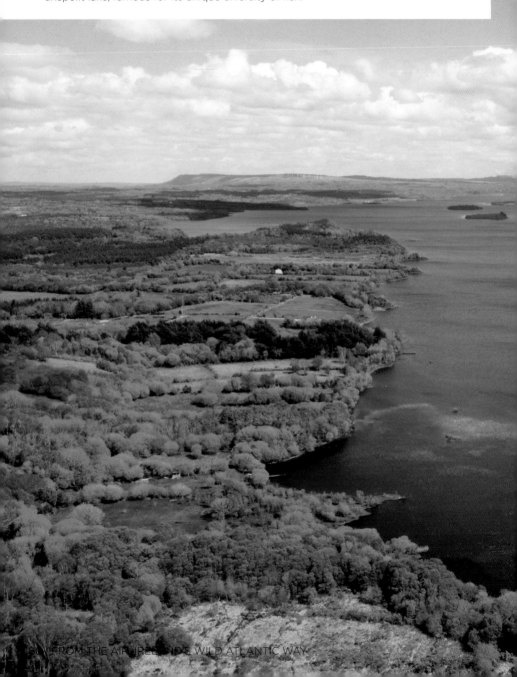

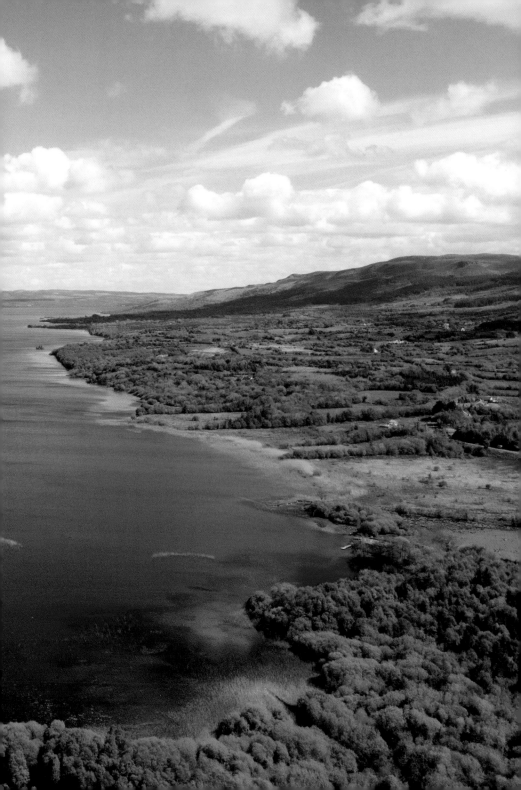

BALLYSHANNON, COUNTY DONEGAL
Slightly upstream from the mouth of the River Erne is the picturesque town of Ballyshannon. It lays claim to being the oldest town in Ireland, and it is also the birthplace of blues guitar legend Rory Gallagher.

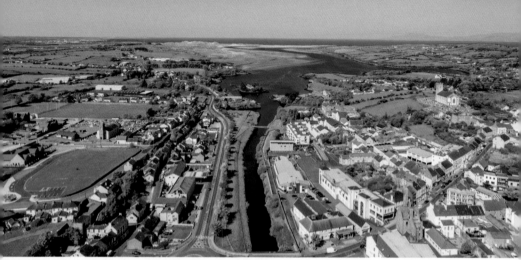

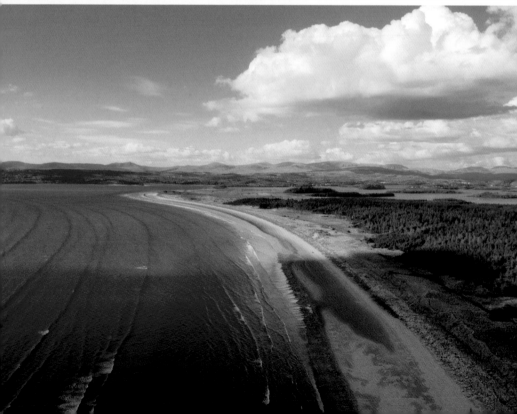

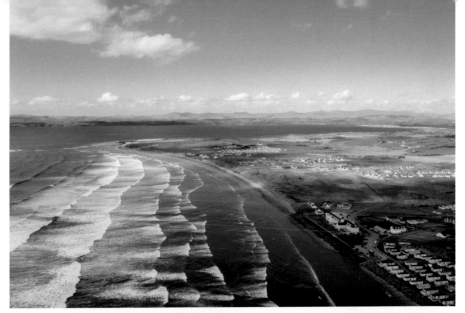

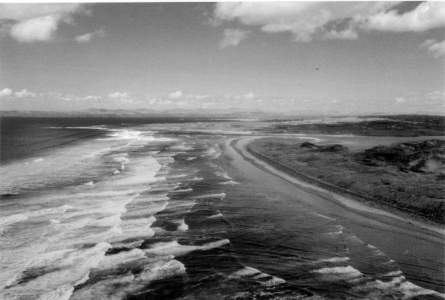

BELOW LEFT: MURVAGH BEACH, COUNTY DONEGAL
This 2km-long beach is popular with walkers and horse riders alike. Featuring extensive sand dunes, which lead into Murvagh forest, it is an ideal spot for picnics.

TOP: ROSSNOWLAGH BEACH, COUNTY DONEGAL
8km south of Donegal town, Rossnowlagh beach beckons visitors from far and wide, with its soft, golden sand and great views. Surfing is hugely popular here and is great for beginners.

ABOVE: TULLAN STRAND, COUNTY DONEGAL
One of Donegal's most renowned surfing beaches, located at the town of Bundoran, Tullan features sweeping sand dunes and great views of the Leitrim and Sligo mountains.

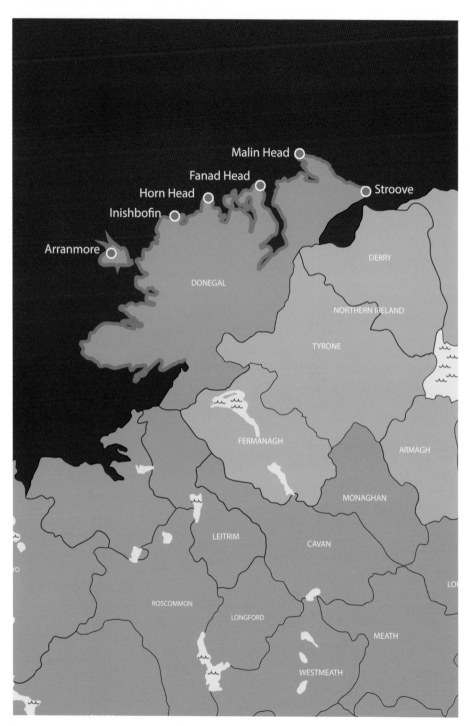

Malin Head

Fanad Head

Horn Head

Inishbofin

Arranmore

DERRY

DONEGAL

NORTHERN IRELAND

Stroove

TYRONE

FERMANAGH

ARMAGH

MONAGHAN

LEITRIM

CAVAN

ROSCOMMON

LONGFORD

MEATH

WESTMEATH

NORTHERN HEADLANDS

Donegal's remote,
wild and rugged beauty,
from Killybegs to Malin Head

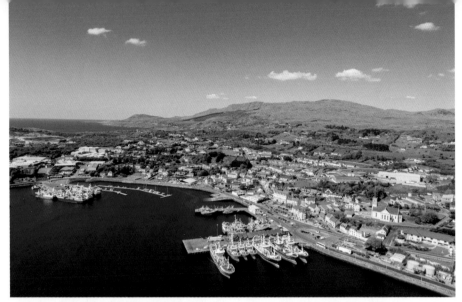

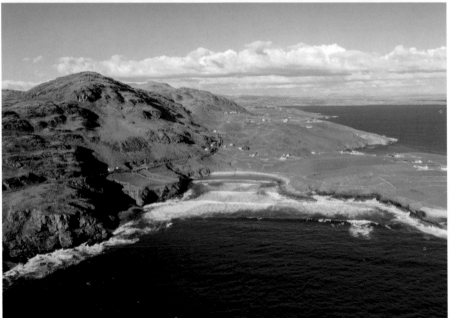

TOP: KILLYBEGS, COUNTY DONEGAL
One of Ireland's most famous fishing ports, Killybegs is a haven for anglers. Many local fisherman run sightseeing and fishing tours, exploring Donegal's epic coastline.

ABOVE: MUCKROSS HEAD, COUNTY DONEGAL
This narrow peninsula is set against the slopes of a small mountain range. A pit-stop on the road here offers magnificent views over the beach and across Donegal Bay to Sligo.

ABOVE RIGHT: MALIN BEG, COUNTY DONEGAL
Silver Strand beach at Malin Beg is dramatically surrounded by a horseshoe of cliffs, accessible by a long staircase. Down the coast stand the remains of a Napoleonic-era watch tower.

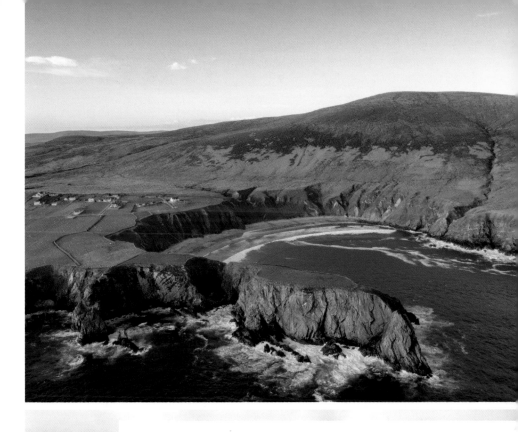

GLENGESH PASS, COUNTY DONEGAL
Going from Glencolumbkille to Ardara, the road descends from 250 metres above sea level, winding around hairpin bends to the majestic Glengesh Pass. It's the perfect picnic spot.

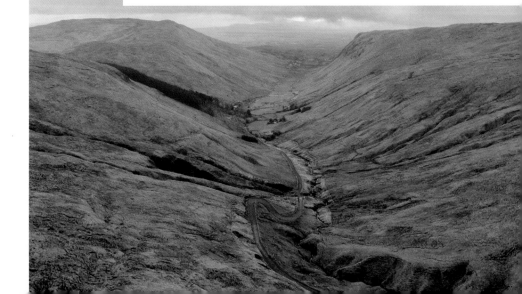

INISHBOFIN, COUNTY DONEGAL

The 300-acre Inishbofin is an island of two halves, connected by a narrow, sandy stretch of land. A cluster of houses lies on the eastern part, lived in year-round until the 1970s. The incredible views from the island make a visit very worthwhile.

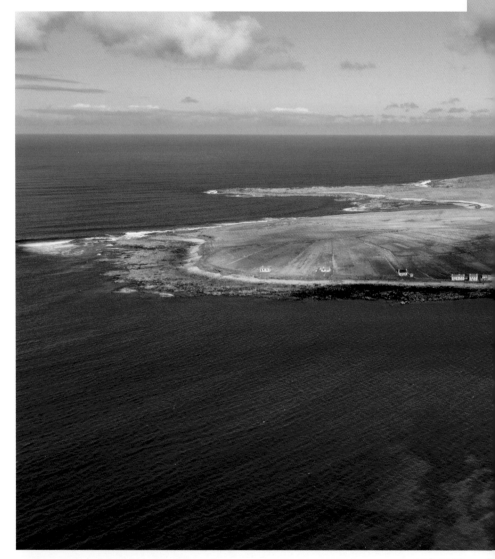

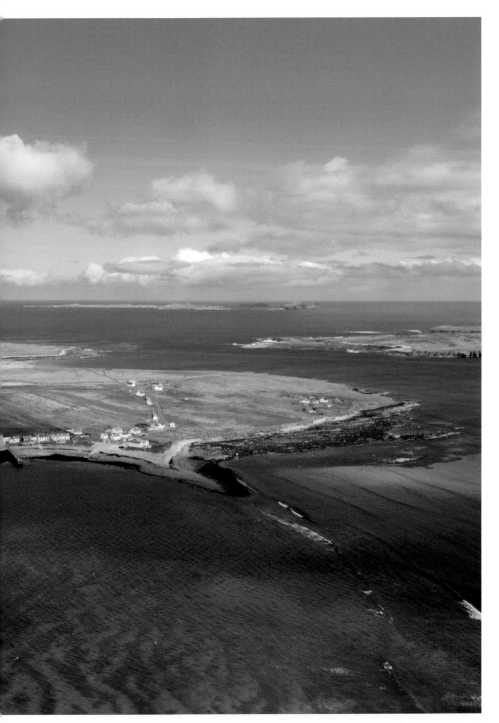

ARRANMORE, COUNTY DONEGAL

The largest of Donegal's islands, accessible by ferry from Burtonport, Arranmore offers sandy beaches and picturesque lakes, with excellent views from the steep cliffs on the western side. A great place for rock climbing, fishing and diving.

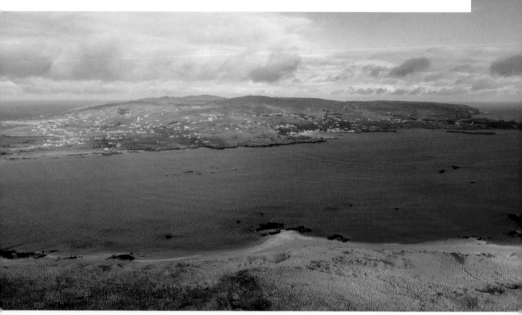

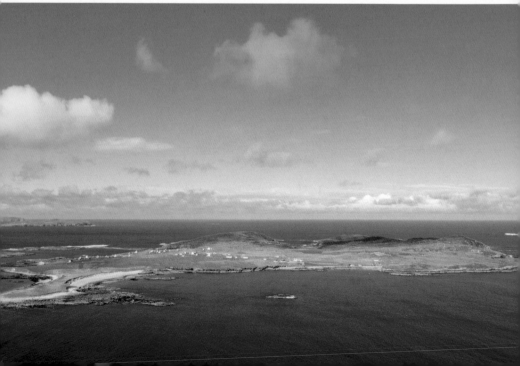

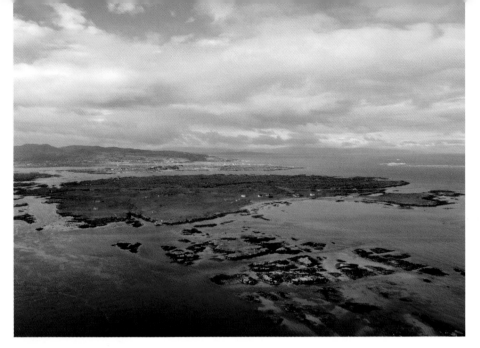

**BELOW LEFT: GOLA,
COUNTY DONEGAL**
This little island, which can
be explored in a few hours,
feels like its own isolated
world. 2km off the coast,
Gola is accessible by ferry
from Magheragallan.

**ABOVE: INISHFREE,
COUNTY DONEGAL**
Uninhabited for a time, like
many islands on Ireland's
western shores, people
have begun to move back
here in recent decades,
perhaps attracted by an
undeniable air of spirituality.

**BELOW:
MAGHERAROARTY,
COUNTY DONEGAL**
The beach at Magheraroarty
is as pure and unspoilt as
a beach can get. Donegal's
tallest peak, Mount Errigal,
stands imposingly on the
southern horizon.

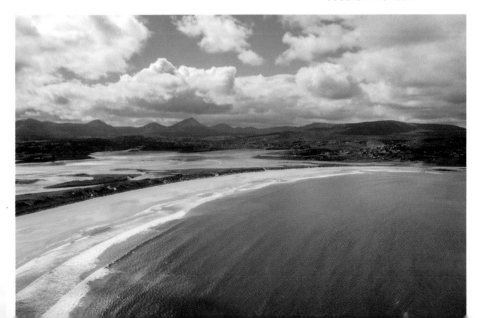

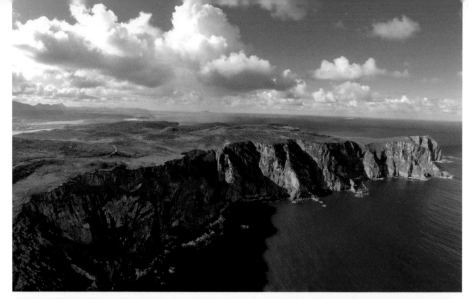

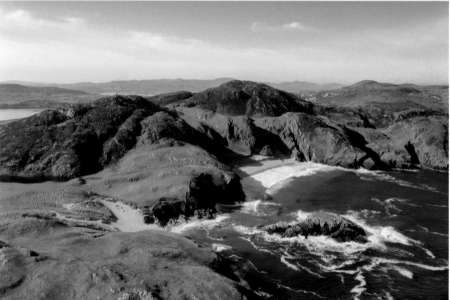

TOP: HORN HEAD, COUNTY DONEGAL

Close to Dunfanaghy, the cliffs of Horn Head are breathtakingly beautiful, rising to 200 metres above the ocean, with excellent views all round and the remains of a Napoleonic-era watchtower.

** HIDDEN GEM **
ABOVE: MURDER HOLE BEACH, COUNTY DONEGAL

Not affiliated with anything grisly, no roads lead to the mysteriously named Murder Hole beach. A hike over dunes and hills rewards you with spectacular views.

ABOVE RIGHT: DOE CASTLE, COUNTY DONEGAL

Stronghold of the MacSweeney Clan for over 200 years, 16th-century Doe Castle stands majestically on the shore of Sheephaven Bay.

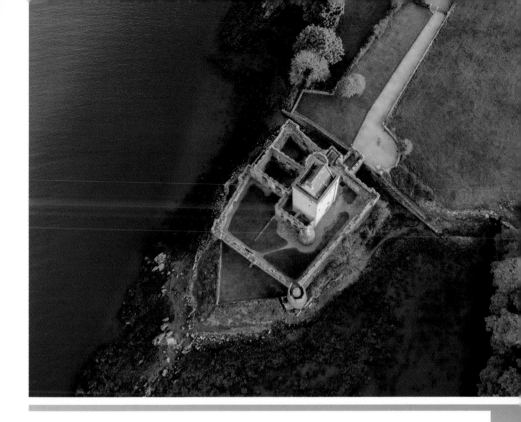

FANAD LIGHTHOUSE, COUNTY DONEGAL

Fanad Peninsula houses one of the most beautiful lighthouses in the world, surrounded by stunning and unforgettable scenery. The lighthouse itself is open for tours, and nature lovers can catch views of the dolphins, whales and porpoises that regularly visit the area.

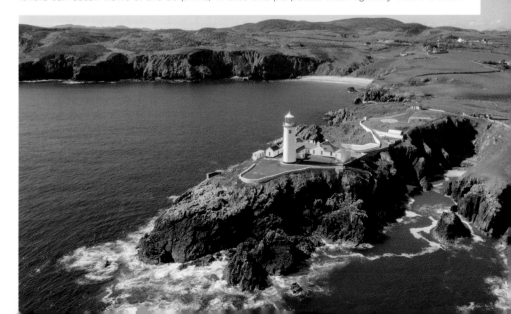

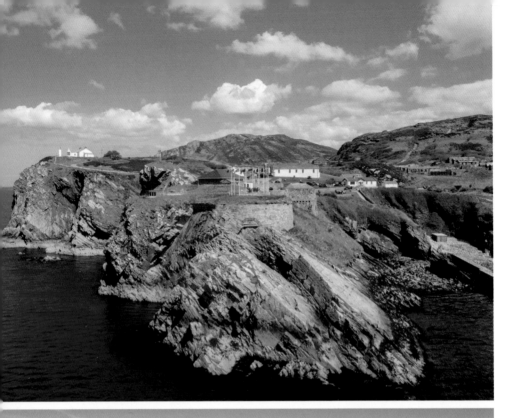

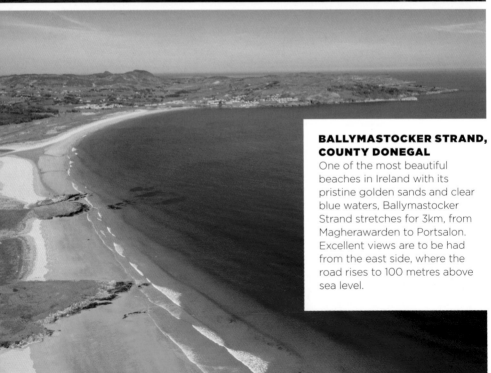

BALLYMASTOCKER STRAND, COUNTY DONEGAL

One of the most beautiful beaches in Ireland with its pristine golden sands and clear blue waters, Ballymastocker Strand stretches for 3km, from Magherawarden to Portsalon. Excellent views are to be had from the east side, where the road rises to 100 metres above sea level.

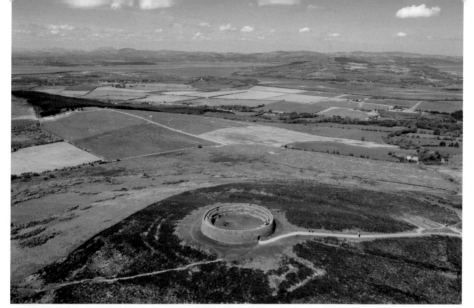

ABOVE LEFT: DUNREE HEAD, COUNTY DONEGAL

Fort Dunree played a significant role since Napoleonic times in protecting the entrance to Lough Swilly. These days, it serves as a fascinating military history museum, as well as offering stunning coastal views.

ABOVE: GRIANÁN OF AILEACH, COUNTY DONEGAL

Standing defiantly 230 metres above sea level, with some of the finest views in Ireland, Grianán of Aileach is truly mesmerising. The 2000-year-old ringfort is believed to have been built on the site of a fort dating from 500 BC.

BELOW: GAP OF MAMORE, COUNTY DONEGAL

On the west side of the Inishowen Peninsula, the road through Mamore Gap is a terrific driving experience with its dramatic views and ever-shifting landscape.

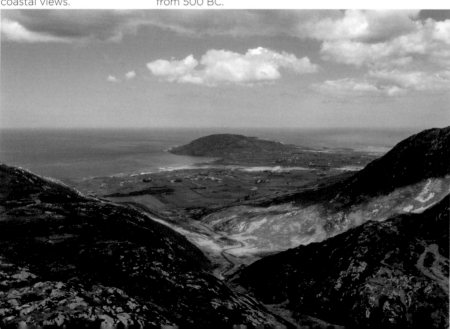

STROOVE LIGHTHOUSE, COUNTY DONEGAL

Featuring two small and beautiful beaches, at either side of the lighthouse, Stroove, 4km from the village of Greencastle, is ideal for exploration on foot.

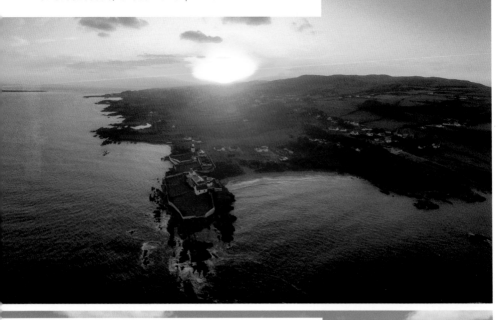

MALIN HEAD, COUNTY DONEGAL

The most northerly point on mainland Ireland, steeped in history and folklore, the landscape here is spectacular and rugged, including some of the largest sand dunes in Europe.

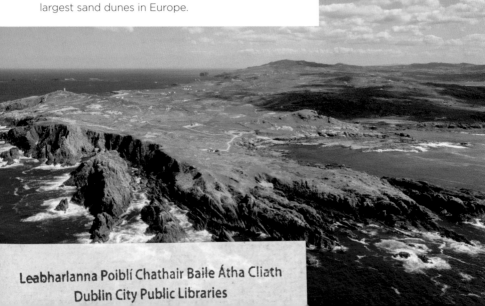